A YEAR FROM MONDAY

A YEAR
FROM MONDAY

New Lectures and Writings by

JOHN CAGE

WESLEYAN UNIVERSITY PRESS

Middletown, Connecticut

ISBN: 0-8195-6002-2
Library of Congress Catalog Card Number : 67-24105
Manufactured in the United States of America
First paperback edition March 1969;
second printing July 1970

To us and all those who hate us,
that the U.S.A. may become just another
part of the world, no more, no less.

CONTENTS

FOREWORD

When *Silence* was published, I gave a copy to David Tudor. After looking it over, he said, "Too bad the *Juilliard Lecture* isn't in it." That text is included in this collection which, except for the *Lecture on Commitment,* written while *Silence* was in preparation, and many of the stories found here and there in this book and those brought together under the title *How to Pass, Kick, Fall, and Run,* consists of what I have been writing since 1961.

The question is: Is my thought changing? It is and it isn't. One evening after dinner I was telling friends that I was now concerned with improving the world. One of them said: I thought you always were. I then explained that I believe—and am acting upon—Marshall McLuhan's statement that we have through electronic technology produced an extension of our brains to the world formerly outside of us. To me that means that the disciplines, gradual and sudden (principally Oriental), formerly practiced by individuals to pacify their minds, bringing them into accord with ultimate reality, must now be practiced socially—that is, not just inside our heads, but outside of them, in the world, where our central nervous system effectively now is.

This has brought it about that the work and thought of Buckminster Fuller is of prime importance to me. He more than any other to my knowledge sees the world situation—all of it—clearly and has fully reasoned projects for turning our attention away from "killingry" toward "livingry."

However, when I recently reread my *Juilliard Lecture,* I was struck by correspondences between the thought in it and the thought I consider most recent in my mind, e.g., "We are getting rid of ownership, substituting use," 1966; and "Our poetry now is the realization that we possess nothing," 1952. My ideas certainly started in the field of music. And that field, so to speak, is child's play. (We may have learned, it is true, in those idyllic days, things it behooves us now to recall.) Our proper work now if we love mankind and the world we live in is revolution.

The reason I am less and less interested in music is not only that I find environmental sounds and noises more useful aesthetically than the sounds produced by the world's musical cultures, but that, when you get right down to it, a composer is simply someone who tells other people what to do. I find this an unattractive way of getting things done. I'd like our activities to be more social

and anarchically so. As a matter of fact, even in the field of music, this is what is happening. Already in the '50's we had the Once Group in Ann Arbor, Michigan, and the Gutai Group in Osaka and Tokyo. Now as one travels around he encounters groups so to speak wherever he goes: the Zaj Group in Madrid, Fluxus here and abroad, Bang[3] in Richmond, Virginia, the construction in Stockholm of the Hon by Niki de Saint Phalle, Jean Tinguely, and Per Olof Ultvedt. When he comes back to New York City, he finds himself in the thick of a group of artists and engineers giving a Festival of Theater and Engineering, a group that plans, under the name EAT (Experiments in Art and Technology), to stay together, as families used to but rarely any longer do. We have moved, one may say, from the time of the family reunion to the present time that brings people and their energies and the world's material resources, energies, and facilities together in a way that welcomes the stranger and discovery and takes advantage of synergy, an energy greater than the sum of the several energies had they not been brought together.

Coming back to the notion that my thought is changing. Say it isn't. One thing, however, that keeps it moving is that I'm continually finding new teachers with whom I study. I had studied with Richard Buhlig, Henry Cowell, Arnold Schoenberg, Daisetz Suzuki, Guy Nearing. Now I'm studying with N. O. Brown, Marshall McLuhan, Buckminster Fuller, Marcel Duchamp. In connection with my current studies with Duchamp, it turns out I'm a poor chessplayer. My mind seems in some respect lacking, so that I make obviously stupid moves. I do not for a moment doubt that this lack of intelligence affects my music and thinking generally. However, I have a redeeming quality: I was gifted with a sunny disposition.

About this book's title (apart from its ambiguity and my interest in non-measurement): it was a Saturday; there were six of us having dinner in a restaurant on the Hudson north of Newburgh; we arranged to meet in Mexico (I've never been in other parts of Mexico than Lower California); three had been in Mexico and were delighted at the prospect of returning; one was born there but hadn't been there for five years; his wife, whom he married in India, like me has never been there; two others, not present at the dinner, both of whom have been in Mexico and love it, hopefully will join us; we may be a party of eight); in order to realize this rendezvous, all of us (knowing how to say Yes) will have to learn to say No—No, that is, to anything that may come between us and the realization of our plan.

—J. C.

x

A YEAR FROM MONDAY

This text was written for publication by Clark Coolidge in his magazine *Joglars,* Providence, R.I. (Vol. 1, No. 3, 1966). It is a mosaic of ideas, statements, words, and stories. It is also a diary. For each day, I determined by chance operations how many parts of the mosaic I would write and how many words there would be in each. The number of words per day was to equal, or, by the last statement written, to exceed one hundred words.

Since Coolidge's magazine was printed by photo-offset from typescripts, I used an IBM Selectric typewriter to print my text. I used twelve different type faces, letting chance operations determine which face would be used for which statement. So, too, the left marginations were determined, the right marginations being the result of not hyphenating words and at the same time keeping the number of characters per line forty-three or less. The present typography follows the original chance-determined plan.

I have several times given this text as a lecture, first at Beloit College in Wisconsin, more recently (June 1966) at the International Design Conference in Aspen, Colorado. It was thereafter reprinted in the spring 1967 issue of *Aspen Magazine.*

DIARY: HOW TO IMPROVE THE WORLD (YOU WILL ONLY MAKE MATTERS WORSE) 1965

I. **Continue; I'll discover where you
sweat (Kierkegaard). We are getting
rid of ownership, substituting use.**
Beginning with ideas. Which ones can we
take? Which ones can we give?
Disappearance of power politics. **Non-
measurement.** *Japanese, he said: we
also hear with our feet. I'd quoted
Busoni: Standing between musician and
music is notation. Before I'd given the
history: chance operations, indeterminacy.
I'd cited the musics of India: notation
of them's after the fact. I'd spoken of*

3

direct musical action (since it's
ears, not interposing eyes). 2:00 A. M.,
Jensen said, "Even if you didn't like
the results (Lindsay, etc.), we hope
you liked the telling of it." Telling
(?) of it! We were there while it was
happening! *II. Minimum ethic: Do what
you said you'd do. Impossible?
Telephone. No answer?* My idea was
that if they wanted to fight (human
nature and all that), they should
do it in the Antarctic, rest of us
gambling on daily outcome: proceeds for
world welfare. Instead they're
cooperative down there, exchanging
data, being friendly. April '64: U.S.
State Department man gave Honolulu
talk—"global village whether we
like it or not"—, cited fifty-five
services which are global in extent.
Mountain range dividing Oahu, formerly
crenelated (crenelations for self-
protection while shooting arrows),
is now tunneled, permitting population
circulation. Wars etc. part of dying
political-economic structures. Social
work equals increasing number of
global services. **III. AS McLUHAN SAYS,**
EVERYTHING HAPPENS AT ONCE. IMAGE IS
NO LONGER STREAM FALLING OVER ROCKS,
GETTING FROM ORIGINAL TO FINAL PLACE;
IT'S AS TENNEY EXPLAINED: A VIBRATING
COMPLEX, ANY ADDITION OR SUBTRACTION
OF COMPONENT(S), REGARDLESS OF APPARENT
POSITION(S) IN THE TOTAL SYSTEM,
PRODUCING ALTERATION, A DIFFERENT MUSIC.

FULLER: AS LONG AS ONE HUMAN BEING IS
 HUNGRY, THE ENTIRE HUMAN RACE IS
HUNGRY. City planning's obsolete. What's
 needed is global planning so Earth
 may stop stepping like octopus on its
own feet. Buckminster Fuller uses his
 head: comprehensive design science;
inventory of world resources. Conversion:
 the mind turns around, no longer
 facing in its direction. Utopia?
 Self-knowledge. Some will make it,
 with or without LSD. The others? Pray
 for acts of God, crises, power
 failures, no water to drink. *IV. We*
see symmetrically: canoe on northern
 Canadian lake, stars in midnight sky
repeated in water, forested shores
 precisely mirrored. Our hearing's
asymmetrical: noticed sounds surprise us,
echoes of shouts we make transform our
voices, straight line of sound from us to
 shore's followed by echo's slithering
 around the lake's perimeter. When I
 said, "Fifty-five global services,"
California Bell Telephone man replied
 (September '65), "It's now sixty-one."
The seasons (creation, preservation,
 destruction, quiescence): this was
 experience and resultant idea (no
longer is: he flies to Rio). What shall
we wear as we travel about? A summer suit
 with or without long underwear? What
 about Stein's idea: People are the way
their land and air is? **V.** When I said
 that culture was changing from

5

Renaissance to what it is now (McLuhan),
Johns objected to what he said was
an oversimplification. But Johns was
speaking according to our non-
Renaissance experience: total field, non-
focused multiplicity. **We are, are we not,**
socially speaking, in a situation of
the old dying and the new coming into
being? For the old—paying bills,
seeking for power—take the attitude
of play: games. For the new—doing what
isn't necessary, "moving sand from one
part of the beach to another"
(Buckminster Fuller)—take the
religious attitude: cerebration. (It
celebrates.) The people have left.
The cat and kittens were taken to the
SPCA. The house is full of fleas. VI.
They say totally determined music and
indeterminate music sound the same. I
visited Hamada. Getting up from
the wheel, he said, "I'm not interested
in results; just going on. Art's in
process of coming into its own: life.

The lake is undefined. The land around
rests upon it obscuring its shape, shape
that needs to remain unrevealed. Sung.
"Floating world." Rain, curtain of wind-
swept lake's surface beyond: second view
(there are others, he tells me, one with
mists rising). Yesterday it was stillness
and reflections, groups of bubbles. An
American garden: water, not sand,
vegetation, not stones. Thunder.
Without intending to, I'm going from lake
to lake. Saltair. Salt Lake. VII.

Hugh Nibley. I hadn't seen him since
 high school days. I asked him what
he thought about other planets and
 sentient populations. Yes, he said,
throughout the universe: it's Mormon
doctrine. We'd said good-bye. I opened
 the door of the car, picked up my
attaché case and everything in it fell
 out on the grass and the gutter. His
 comment: Something memorable always
happens. Things we were going to do are
now being done by others. They were, it
 seems, not in our minds to do (were we
or they out of our minds?) but simply
ready to enter any open mind, any mind
 disturbed enough not to have an idea in
 it. VIII. *The daily warmth we*
experience, my father said, is not
transmitted by Sun to Earth but is what
 Earth does in response to Sun.
 Measurements, he said, measure
 measuring means. Bashô: Matsutake ya
 shiranu ko no ha no hebaritsuku.
The leaf of some unknown tree sticking
on the mushroom (Blythe). Mushroom does
not know that leaf is sticking on it
(Takemitsu). Project: Discover way to
translate Far Eastern texts so western men
 can read orientally.
Communication? Bakarashi! Words
 without syntax, each word
polymorphic. He wanted me to agree that
the piano tuner and the piano maker have
 nothing to do with it (the composition).
The younger ones had said: Whoever makes
 the stretcher isn't separate from the

7

painting.　　(It doesn't stop there
either.)　　IX.　　**LOOKING IN ALL DIRECTIONS
NOT JUST ONE DIRECTION.**　　Housing
(Fuller) will be, like telephoning, a
service.　　Only circumstance to stop your
living there: someone's there already
　　　　　　　(it's busy).　　Thus we'll learn to
desire emptiness.　　Not being able to say,
"This is mine," we'll want when we
inquire to get no response at all.　　4:00
　　　　　　　P. M. throughout the world.　　Whether
　　　　　　　we like it or not (is what he said)
it's happening to us.　　**Advertisements are
all good; the news is all bad (McLuhan).
But how we receive bad news can change:
we're glad to hear unemployment's
increasing.**　　**Soon, all that will be
required of us will be one hour's
work per year (Fuller).**　　X.　　*They ask what
the purpose of art is.　　Is that how
things are?　　Say there were a thousand
artists and one purpose, would one
artist be having it and all the nine
hundred and ninety-nine others be
missing the point?*　　**Arcata Bottom sign
said: Experiment endlessly and keep
humble.**　　"Write to Center for the Study
　　　　　　　of Democratic Institutions; they'll
know about the global services."　　I
did.　　They answered they knew nothing,
　　　　　　　suggested writing to State Department.
Books one formerly needed were hard to
　　　　　　　locate.　　Now they're all out in
paperback.　　Society's changing.
　　　　　　　Relevant information's hard to come
by.　　Soon it'll be everywhere, unnoticed.

XI. **ELECTRONICS.** Day comes, the day we
 die. *There's less and less to do:*
 circumstances do it for us. Earth.
 Old reasons for doing things no
 longer exist. (Sleep whenever. Your
work goes on being done. You and it no
 longer have a means of separation.)
 We had the chance to do it
 individually. Now we must do it
 together: globally. War will not be
 group conflict: it'll be murder, pure
 and simple, individually conceived.
 Curiosity, awareness. They returned to
 the fact we all need to eat to explain
their devotion to money rather than music.
 When I spoke of the equation, work
 equals money equals virtue, they
 interrupted me (they didn't let me say
that nowadays there's no equation),
 saying, "How can you speak of money and
virtue in the same breath?" XII. **WHERE**
 THERE DOESN'T SEEM TO BE ANY SPACE,
 KNOW WE NO LONGER KNOW WHAT SPACE IS.
 HAVE FAITH SPACE IS THERE, GIVING ONE
 THE CHANCE TO RENOVATE HIS WAY OF
 RECOGNIZING IT, NO MATTER THE MEANS,
 PSYCHIC, SOMATIC, OR MEANS
 INVOLVING EXTENSIONS OF EITHER.
 People still ask for definitions, but
 it's quite clear now that nothing
 can be defined. Let alone art, its
 purpose etc. We're not even sure of
 carrots (whether they're what we think
 they are, how poisonous they are, who
 grew them and under what circumstances).
 SHE WAS INDIGNANT WHEN I SUGGESTED

THE USE OF AN APHRODISIAC. WHY?
 NATURALLY SHE CONSIDERS TV A WASTE OF
 TIME. XIII. The purpose of one
activity is no longer separate from the
 purpose of any other activity. All
 activities fuse in one purpose which
is (cf. Huang-Po Doctrine of Universal
 Mind) no purpose. Imitate the
Ganges' sands, becoming indifferent to
 perfume, indifferent to filth.
Influence. Where does it come from?
Responsibility? Sick ones now are
 heartsick. Narcissi, they became
 entranced with emotions, purposes,
 mystified by living in the twentieth
 century. We've invented something else,
 not the wheel. We extended nervous
systems. McLuhan: Agenbite of Outwit
(Location, Spring '63). (The inability of
 people to be inactive. As Satie said:
 If I don't smoke, someone else will in
 my place. Audience participation,
 active passivity.) XIV. Since the
Spirit's omnipresent, there's a difference
 in things but no difference in spirit.
 McLuhan was able to say "The medium is
 the message" because he started from
no concern with content. Or choose
 quantity, not quality (we get
 quality willy-nilly) : i.e. we'd like
 to stay alive, the changes that are
taking place are so many and so
 interesting. Composition'll have, he
 said, less and less to do with what
 happens. Things happen more
quickly. One of the signs you'll get

10

that'll tell you things are going well is
that you and everyone else you know will
 be inhabiting lightweight Dymaxion
houses, disengaged from ownership and
 from violated Earth spot (read
 Fuller). **XV. Smiling, she said, let
 the old ones walk out: there's not
 much to be done about them in any case.**
**Distractions? Interruptions? Welcome
 them. They give you the chance to
 know whether you're disciplined. That
 way you needn't bother about sitting
 cross-legged in the lotus position.**
Phonetics. *He was a physicist and a
 computer-composer in his spare time.
 Why was he so stupid? Because he was
 of the opinion that the only thing
that will engage the intellect is the
measurement of relations between things?
 When told that his mind could change,
 his response was, "How? Why?"* Conflict
won't be between people and people but
between people and things. In this
 conflict let's try to arrange matters so
 the outcome as in philosophy will
 never be decisive. Treat redwoods, for
 instance, as entities that have at
least a chance to win. **XVI. He
 wanders through markets as though
they were forests and he an exploring
 botanist (throws nothing away). Lake.
 Take what you're working on with
 you, if, that is, you have
something to do. Gaps. What a pity
 that she should feel obliged to take
 matters in her own hands! (There's**

practically no kitchen, he says, and
 it's already been figured out that
 money's being saved.) Mexico.
 Europeans are still up against it.
They seem to require a center of
 interest. They understand tragedy but
life itself (and any art that's like it)
 puzzles them, seems unsatisfactory.
 We're starved for entertainment
 (thanking the two women). XVII. By
becoming angry I simply altered my
biochemistry, bringing about a two-hour
 recovery. Meanwhile circumstances
continued characterized by habit. *Going*
in different directions we get instead of
 separation a sense of space. **Music as**
 discourse (jazz) doesn't work. If
 you're going to have a discussion,
 have it and use words. (Dialogue is
 another matter.) Acts and facts.
 Straw that breaks the camel's back:
 their saying No (they advertise they'll
 say Yes). *Principles?* *Then all's*
 intolerable. No principles (which
 doesn't mean we fail to become
 furious). *So?* *We swim, drowning now*
 and then. *I must write and tell him*
 about beauty, the urgency to avoid
 it. XVIII. Hearing of past actions
 (politics, economics), people soon
 won't be able to imagine how such
 things could've happened. Fusing
 politics with economics prepared
 disappearance of both. Still
 invisible. **Arriving, realizing we**
 never departed. He mentioned heads

on the ceiling. Seeing them, noticed
him too. Fusion of credit card with
passport. Means of making one's voice
heard: refusal to honor credit card.
End of the month? That too may be
changed: the measurement of time,
what season it is, whether it's
night or day. In any case, no bills,
just added information. **"Take it easy,
but take it."** What'll we do? (Before
lunch.) "Wing it." **XIX. Wanting list of
current global services, how'll I get
it? Long costly correspondences?
(Pentagon advises telephoning.) I'll
write to the President (of the U.S.), to
the Secretary (of State of the U.S.).
Time passing, I'll ask those I
encounter whether they've any
information. (McLuhan hadn't any.)
I'll write to Fuller. Should have done
that in the first place (Pope Paul,
Lindsay: Take note).** Amateur (used to
say, "Don't touch it!") now speaks of
audience participation, feels something,
anything, is needed, would help. Develop
panopticity of mind (Listen). **WHAT'LL
HAPPEN WHEN INTELLIGENCE IS RECOGNIZED
AS A GLOBAL RESOURCE (FULLER)?
POLITICAL ORGANIZATIONS—GIVING UP
INVOLVEMENT WITH PLAY (PARTNERS,
OPPONENTS), INVOLVEMENT WITH UNATTAINABLE
GOALS (VICTORIES, TRUTHS,
FREEDOMS)—WILL SIMPLY FADE OUT OF THE
PICTURE. IMAGE COMING UP IS THAT OF
THE UTILITIES (GAS, ELECTRICITY,
TELEPHONES): UNQUESTIONABLE, EMOTIONALLY**

**UNAROUSING. XX. What is a drawing?
No one knows any longer. Something
that doesn't require that you wait
while you're making it for it to dry?
Something on paper? Museum director
said (Tobey, Schwitters), "It's a
question of emphasis." Thanksgiving.**

Art. Transportation plan (eventually at no
monetary cost, conveyances recognized
for what they are: extensions of each human
being and his luggage): short distances
costly (to taxi for one block is a
luxury), long trips cheap as dirt
(crossing continents, oceans). Effect of
videophone on travel? That we'll
stay home, settling like gods for
impressions we'll give of being
everywhere at once? *XXI. Everywhere
where economics and policitics obtain
(everywhere?), policy is dog eat dog.
Take taxi tolls between cities. Those
in one town higher than those in the
other. Driver going from one to the
other must drive home alone. Relaxation
of rules, ties (Take marriage), is
indicated.* Now that we've got the
four-lane roads, we won't have any use for
them. (Good for roller-skating, he said.)
Refuse value judgments. **Since
time lags were inordinately long,
change's now welcome.** Advertising's
discredited itself. When they
advertise something, we avoid it.
*There's nothing we really need to do that
isn't dangerous. Eighth Street
artists knew this years ago: constantly*

spoke of risk. But what's meant by risk?
Lose something? Property, life?
Principles? The way to lose our
principles is to examine them, to give
them an airing. XXII. Heaven's no
longer paved with gold (changes in
church architecture). Heaven's a motel.
She changed part of the loft: wall-to-wall
carpeting, mobile TV. No conflicts.
Twenty-two telephone calls were made
by Betty Zeiger "disrupting efficiency
of federal agencies . . . dedicated to
pursuit of peace." State Department
said Hawaii speaker was a woman.
Fifty-five (now sixty-one) global services
are in area of humanities "beyond
mere provision of food/shelter." Not
technological services. *State Department:*
Global village developed from
"Literary Villages" (plan for the
betterment of life in India). "We are
packages of leaking water." "The next
water you drink may be your own."
XXIII. LET'S CALL IT THE
COLLECTIVE CONSCIOUSNESS (WE'VE GOT
THE COLLECTIVE UNCONSCIOUS). THE
QUESTION IS: WHAT ARE THE THINGS
EVERYONE NEEDS REGARDLESS OF LIKES
AND DISLIKES? BEGINNING OF ANSWER:
WATER, FOOD, SHELTER, CLOTHING,
ELECTRICITY, AUDIO-VISUAL
COMMUNICATION, TRANSPORTATION. FORM
OF ANSWER: GLOBAL UTILITIES NETWORK. Do
not fear that as the globe gets utility
organized your daily life will not
remain (or become as the case may be)

disorganized, characterized by chaos,
illuminated anarchically. You'll
have nothing to do; so what will you
do? A lifelong university
(Fuller)? In the lobby after La
Monte Young's music stopped,
Geldzahler said: It's like being in a
womb; now that I'm out, I want to get
back in. I felt differently and so did
Jasper Johns: we were relieved to be
released. XXIV. Knowing-seeing,
conforming with reality. *Anscombe's*
a feminist, insists on wearing pants.
Obliged to lecture dressed in a
dress, she took one with her,
changed into it, lectured, changed back,
walked home (teaching all the time) in
pants. As was said, "When will you
undress yourself of your ideas?" No
escape. Billy Klüver said decision
of judge in South America (e.g.) is
taken as precedent by judge in Sweden.
Brown's work (Life Against Death) is
prophetic (also de Kooning's remark: we no
longer have tragedy; the situation an
individual may be in is only pathetic):
society as a mass is what needs
psychoanalysis. (Thus polymorphous
perversity, necessity of Utopia.) Looking
at billions, unlike Nehru, we must
treat them as one person. **XXV. SHE**
SAYS LIFE IS LIKE A BLANK WALL,
IMPASSIBLE. CORRECT DEDUCTION: SHE IS
IN LOVE. Klüver: ITU lists many
international agreements re Morse code,
telegrams, telephones, radio, television,

emergency signals, meteorological
information, frequencies and powers
of stations, means to prevent
static. "How would it be if these
agreements didn't exist?" (ITU asks.)
"No press-news, no pictures in the
papers, no exchanged radio programs, no
static-free radio reception, no
meteorological prognoses, no storm
warnings, no security at sea, in air."
*Klüver reports: ITU (International
Telecommunication Union) was
established in 1865 (nine years
older than UPU—post—and seventeen
older than railroad agreements).* XXVI.
The truth is that everything causes
everything else. We do not speak therefore
of one thing causing another. There
are no secrets. It's just we thought they
said dead when they said bread. Or
that we weren't tuned in when
transmission took place. Being
told about global services, Barnett
Newman emphasized the importance of
the arts. **Society has tape
recorders, radio broadcasts, and also
copyright laws (which it considers
extending).** (Gets in its own way.) Get
rid of copyright (this text is
copyright). **We're making
nonspecialist interpenetrations.**
Automation. Alteration of global
society through electronics so that world
will go round by means of united
intelligence rather than by means of
divisive intelligence (politics,

17

economics). Say this idea has no basis
in fact but arose through brushing of
 misinformation. No sweat. It arose
 (the idea exists, is fact). XXVII.
Do not imagine there aren't many things
 to do. We need for instance an
 utterly wireless technology. Just as
Fuller domes (dome within dome,
 translucent, plants between) will give
 impression of living in no home at
 all (outdoors), so all technology
 must move toward way things were
 before man began changing them:
identification with nature in her manner
of operation, complete mystery. Fuller
 prophecy at end of Tomkins profile
 of him editorially (New Yorker)
 eliminated. Subject: global
network for electrical power (including
 China who'd participate in a spirit
of practicality). Fuller's remarks
 considered laughable in view of
 November blackout. (We need another
 blackout, one that isn't so pleasant,
one that'll suggest using our heads the
way Fuller uses his.) XXVIII. We've
 poisoned our food, polluted our air
 and water, killed birds and cattle,
 eliminated forests, impoverished,
 eroded the earth. We're unselfish,
 skilful: we include in our acts to
 perform—we've had a rehearsal—
 the last one. What would you call it?
 Nirvana? "Not only was instant
universal voice communication forecast
 by David Sarnoff, but also instant

television, instant newspapers, instant
magazines and instant visual
telephone service . . . the development of
such global communications system
would link people everywhere . . . for
reorientation toward a 'one-world
concept of mass communications in an
era marked by the emergence of a
universal language, a universal
culture and a universal common
market.' " **XXIX.** **POPULATION.**
Art's obscured the difference between
art and life. Now let life obscure
the difference between life and art.
Fuller's life is art: comprehensive
design science, inventory of world
resources (if enough mined copper
exists, re-use it, don't mine more:
same with ideas). World needs
arranging. It'll be like living a
painting by Johns: Stars and
Stripes'll be utilities, our daily
lives the brushstrokes. *McLuhan: Work's*
obsolete. Why? Work's partial
involvement in activity. Activity is
now necessarily total involvement (cf.
work of artists, work not involved in
profit). Why total involvement?
Electronics. Why everything-at-once?
The way we-things are. Yathabhutam.
Where there's a history of
organization (art), introduce disorder.
Where there's a history of
disorganization (world society),
introduce order. These directives are
no more opposed to one another than

19

mountan's opposed to spring
weather. "How can you believe this when
you believe that?" How can I not?
Long life.

--

Mies van der Rohe said, "The least is the most." I agree with him completely. At the same time, what concerns me now is quantity.

• • •

When I got a letter from Jack Arends asking me to lecture at the Teachers College, I wrote back and said I'd be glad to, that all he had to do was let me know the date. He did. I then said to David Tudor, "The lecture is so soon that I don't think I'll be able to get all ninety stories written, in which case, now and then, I'll just keep my trap shut." He said, "That'll be a relief."

• • •

A very dirty composer was attempting to explain to a friend how dirty a person was whom he had recently met. He said, "He has dirt between his fingers the way you and I have between our toes."

• • •

A lady carrying many packages got on a Third Avenue bus. Before she was able to get to a seat, the bus lurched forward. The packages fell, several of them on a drunken bum who had been muttering to himself. Looking up at the lady blearily, he said, "Whashish?" The lady answered cheerfully, "Those are Christmas presents, my good man; you know, it's Christmas." "Hell," he said, "thawashlashyear."

• • •

David Tudor gives the impression of not being overly fond of mushrooms. But one night he had two helpings of morels and then finished the dish completely, including the juice. The next afternoon while he was shaving I read out loud the following quotation from Leonardo da Vinci: "Lo! Some there are who can call themselves nothing more than a passage for food, producers of dung, fillers up of privies, for of them nothing else appears in the world nor is there any virtue in their work, for nothing of them remains but full privies." David Tudor said, "Perhaps they were good Buddhists."

• • •

My grandmother was sometimes very deaf and at other times, particularly when someone was talking about her, not deaf at all. One Sunday she was sitting in the living room directly in front of the radio. She had a sermon turned on so loud that it could be heard for blocks around. And yet she was sound asleep and snoring. I tiptoed into the living room, hoping to get a manuscript that was on the piano and to get out again without waking her up. I almost did it. But just as I got to the door, the radio went off and Grandmother spoke sharply: "John, are you ready for the second coming of the Lord?"

• • •

The day after I finally won the Italian TV quiz on mushrooms, I received anonymously in the mail Volume II of a French book on mushrooms that had been published in Germany. I was studying it in a crowded streetcar going to downtown Milan. The lady next to me said, "What are you reading that for? That's finished."

• • •

"Elizabeth, it is a beautiful day. Let us take a walk. Perhaps we will find some mushrooms. If we do, we shall pluck them and eat them." Betsy Zogbaum asked Marian Powys Grey whether she knew the difference between mushrooms and toadstools. "I think I do. But consider, my dear, how dull life would be without a little uncertainty in it."

Just before setting out for Saskatchewan to conduct a music workshop at Emma Lake in July 1965, I received a request from the editor of *Canadian Art* for an article having fifteen hundred words. Since I was busy with a number of projects, I was on the point of replying that I had no time, when I noticed that I would be at the workshop for fifteen days and that if I wrote one hundred words a day it wouldn't be too much for me and the magazine would get what it wanted. I then replied with a certain firmness telling the editor that I would only do this if he would accept my work in advance, not change it in any way typographically, and let me see and correct proof (I was still cross with the editors of the *Kenyon Review* because of the way they had treated my text on Schoenberg's *Letters*). Everything was agreed to, and when the proof came there was nothing in it to correct. However, when it was printed in the January 1966 issue, a head-note accompanied it which suggested the frame of mind a reader might have were he to enjoy my text. Explanatory notes followed. All of that material is here omitted.

Instead of different type faces, I used parentheses and italics to distinguish one statement from another. I set the text in a single block like a paragraph of prose. Otherwise I used the mosaic-discipline of writing described in the note preceding *Diary: How to Improve* etc. *1965*.

DIARY: EMMA LAKE MUSIC WORKSHOP 1965

August 15. The role of the composer is other than it was. Teaching, too, is no longer transmission of a body of useful information, but's conversation, alone, together, whether in a place appointed or not in that place, whether with those concerned or those unaware of what is being said. We talk, moving from one idea to another as though we were hunters. *Christopher Lake Line Four Ring Two-One. Operator doesn't answer.* Everyone who's coming's still coming, others leaving for a day. (By music we mean sound; but what's time? Certainly not that something begins and ends.) August 16. This is the day the workshop opens, but due to circumstances—a concert in Saskatoon—it opened yesterday. Tomorrow? (Hunted mushrooms in muskeg nearby. Got lost.)

(Missed lunch.) *Correspondence.* Listening to music, what do I do? Those musical conventions assume I recognize relationships. They give no exercise to my faculty to reach the impossibility of sufficient auditory memory to transfer from one like event to another the memory imprint (Duchamp paraphrased). I managed in the case of Mozart to listen enthusiastically to the held clarinet tones. They *reminded* me of feedback. August 17. Plan: to meet as a group every day at four in the afternoon for discussion of my current concern: music without measurements, sound passing through circumstances. ¶ The room where we meet is a biological laboratory. There's a piano and an oven for drying fungi. We leave our music on tables there (each in the group has access to whom, as musicians, the others are). *Each person is free to bring me his work, to discuss it with me privately. What else that happens happens freely: going to get a pail of water at the pump, I pass by the lab; two of them are in there talking about Vivaldi.* August 18. First student was easy to teach: i.e., don't consider your composition finished until you've heard it performed. (Today we had the second group meeting. During the first I had described *Variations V* for which I've not yet made a "score." This involved me in a brief history of electronic music and finally a description of the antennae, photoelectric devices, etc., which enabled dance movements to trigger sound sources.) Two more students visited: one with a poem and sense of drama. The other's young. Is he also gifted? August 19. (The geologist leaves tomorrow. Our talks involved him in computer music; there's a computer in his office in Calgary. He had written symphonic music which no orchestra ever played. Now he sees music as programming.) It seems a wild goose chase: examining the fact of musical composition in the light of *Variations V,* seeing composition as activity of a sound system, whether made up of electronic components or of comparable "components" (scales, intervalic controls, etc.) in the mind of a man. *Five more people in the workshop today.* August 20. Today's yesterday. What happened? Hunted fungi; lunch; took notes on *Leccinum* species; discussed their work with two composers; continued component inquiry—discussing Young, Brown, Kagel; dinner—food's getting serious: no green vegetables; Alloway lecture on pop and op; boat ride after midnight: "Wow!" *Started exhibit of mushrooms in dining room,*

giving Latin names and remarks about edibility. There's a convincing young poet here (his physical stance, his energy of spirit, his face). He wants his poetry to be useful, to improve society. Will he only make matters worse (Kwang-Tse)? August 21. [He knows about canon and permutations. Does he need to know about variation (Alloway's talk about op and systematic art)?] It's the place, the people, the land and air with its mosquitoes and all, more than that it's music and painting: zoologists, poets, potter, they too are with it. *Buckminster Fuller: the practicality of living* here *or there.* A teacher should do something other than filling in the gaps. (Gave my lecture *Where Are We Going? and What Are We Doing?*—four texts superimposed. Seems to me the life has just about gone out of it.) *Questions.* No tundra, nevertheless a northern sense of heightened well-being. ¶ Another farewell. August 22. Lindner invited several of us to see his paintings: observation of nature—stumps with moss and lichen; skilful rendering of what he sees. His devotion is to his foregrounds; the backgrounds are best when he doesn't do them at all: just leaves the surface unpainted. Viennese, he settled in Saskatchewan. Self-taught, he spent his life teaching others in the high schools here. *Gathered wild raspberries.* Alloway informed, intelligent, sympathetic; Godwin straight-forward: conversation re Godwin's paintings. (Diary.) Rick Miller and I gathered many *boletes.* Plan: to cook them, say, for twenty people. But which twenty? The people have become a family. Fortunately, there were enough mushrooms for everyone (everyone who dared eat them). August 23. The one with the poem is getting along well, given structure, writing parts, score later. *Posted dried fungi with notes and spore-prints to Smith.* Several after lunch off to Lindner's muskeg. Found a large stand of *Hydnum repandum.* When others left for a nearby lake, refused to leave. Arranged to meet on road at 4:00. 3:30 started back. 4:00 hurried. 6:30 lost. Yelling, startled moose. 8:00 darkness, soaked sneakers; settled for the night on squirrel's midden. (Family of birds; wind in the trees, tree against tree; woodpecker.) Fire. ¶ Roasted *L. aurantiacum.* Rationed cigarettes (one every three hours: they'd last 'till noon). Thought about direction (no stars). Where is north? 6-ft. radius. August 24. 5:30 sky overcast. 6:00 aiming for solid dry spots, angry (7:00): full circle back again

(checked that fire was out). Goal: walk in one direction. *Mushrooms.* Lost cigarettes and wax paper. Recognized path connecting two lakes. Visiting the larger one, passed by *Amanita virosa.* 9:00 heard horn. Shouted. Received reply! Don Reichert and Rick Shaller picked me up. Friendship vs nature: St. Ives denim, ham sandwiches and canoe. (Distinguished between sounds and relationship of them: no sounds.) *Cooked hydnums.* *Gave reading.* Search organized by Jack Sures, potter. DNR men. Fifty people, mostly artists. Helicopter. Dog. Jeep. At night, searchlights, shouts, horns. That night also: loss of mind, cabin destroyed by fire, Mrs. Kaldor hospitalized. August 25. Discussion: fugue. (The question remains unanswered.) Hearing several recordings of his music, was struck by difference between sections, no transitions. Suggested carrying this to extreme (Satie, McLuhan, newspaper): not bothering with cadences. ¶ Made no effort ("Unperformed work isn't finished.") towards workshop concert. Therefore it happened and skilfully: piano solos by Ted Bourré, setting of Duncan poem (two voices—singing, speaking, two pianos and percussion) by Martin Bartlett. Music by Jack Behrens, Boyd McDonald, and myself also heard. (Having missed poetry-reading, heard recording of it. Gerry Gilbert spoke of poetry as voice instead of words on page. Like a dance: human by nature.) August 26. *Art McKay.* What we learn isn't what we're taught nor what we study. We don't know we're learning. Something about society? That if what happens here (Emma Lake) happened there (New York City), such things as rights and riots, unexplained oriental wars wouldn't arise. Something about art? That it's experience shared? That we must have had the experience before we have the art? (Rock 'n Roll. Two couples servicing north with amplifiers, loud-speakers, the ladies dressed in silver.) *Self-education.* [Seminar (last day): answered questions re graphic notation.] Dining room turned into dance-hall. August 27. Cree Indians formerly found a fungus underground, in books called Indian Bread. The Montreal Lake Indians I spoke to, some of them on in years, had never heard of it. Authentic Indian designs are no longer geometric: they're floral. *If they ask you to write some music and tell you what to write, how long, etc. (a commission), do all they ask, I told him, and whatever else, besides, you can.* (Departures at all hours; people arriving,

leaving, and coming back; difference of directions; Mrs. Kaldor, who baked the pies, blueberry and saskatoon, still in the hospital. Shopped for moccasins.) August 28. He'd written a piece in one style and was fulfilling a commission in another. What did I think? O.K. (The one-hundred-year project at Regina: artificial mountain (slides away), artificial lake (weeds grow over), university. The land is flat. How excellent if it could remain so, the people living underground, ready for daily amazement of coming to the surface!) Why did we leave ahead of time? Circumstances? The distances to travel? The fact of weekend? We'd gotten together and so could separate? ¶ There had been a robbery. None of the paintings taken, only the coin collection. *Saskatchewan.*

Peck says that if things are doing well in gardens, one can expect, in the woods, fields, and waste places, to find wild plants doing equally well.

. . .

One winter David Tudor and I were touring in the Middle West. From Cincinnati we drove to Yellow Springs to drum up an engagement for Merce Cunningham and his Dance Company. In this way we met the McGarys. Keith was teaching philosophy at Antioch College and Donna taught weaving and dancing. My conversation with Keith McGary had no sooner begun than we discovered our mutual interest in mushrooms. I told him that I'd never seen the winter-growing *Collybia velutipes.* He opened the front door and, using a flashlight, showed me the plant growing in the snow from the roots of a nearby tree. He told me what difficulty he was having finding books about fungi. I gave him my copy of Hard which I'd brought along. This book deals especially with Ohio mushrooms. The next day I located two copies of the book in a second-hand bookstore in Columbus. I bought them both. Each winter I find the *Collybia,* the velvet footed, in quantity. How is it I didn't notice it during the winters before I met Keith McGary?

Lois Long, Esther Dam, Ralph Ferrara, and I were in the Haverstraw cemetery gathering *Tricholoma personatum.* An elderly lady with a hat on, standing by while a man she was with was tending a grave, happened to notice us. She called out, asking what we were doing there. We said we were looking for mushrooms. Her voice rose slightly as she asked whether Lois Long's Volkswagen which was parked nearby belonged to one of us. The next thing she asked, her voice sharp-edged, was whether we had loved ones buried there. Hearing no one of us did, she spoke firmly and loudly. "Well, I don't like it; and I don't think any one else would like it. If the mushrooms grow here, let them!" Meanwhile the gentleman with her paid no attention. He just went on doing what he was doing. And we, walking dutifully toward the little car, passed by quantities of our favorite mushrooms, making not the slightest attempt to pick them. As we drove off the woman was yelling. "Get out!" she screamed, "get out and never come back!"

. . .

On Yap Island phosphorescent fungi are used as hair ornaments for moonlight dances.

The composer André Boucourechliev conducted an inquiry regarding attitudes toward *Serial Music Today*. I contributed the following article. It was published in *Preuves* (Paris) March 1966.

SERIOUSLY COMMA

Admitting that, no matter what, one thing follows another (Wolff: "becomes a melody"), that there's no space between activities *(Variations III)*, one asserts that this isn't two-dimensional linear-fact (or multiplicity of such facts interrelated) but un-beginning, interminable field-fact. Space, miracle, then arises where there was none.

McLuhan insists on the newspaper front-page as the present existence type. Reading, we no longer read systematically (concluding each column, or even turning the page to conclude an article): we jump.

McLuhan *(Gutenberg Galaxy, Understanding Media)* again: That printing (alphabet: making *b* follow *a* inflexibly) made the Renaissance is evident. Electronics equally is making us.

SHE SPENDS HER
TIME COUNTING
THE PASSING CARS.

MUSIC'S NOT WAITING, BUT
SINGS FINAL DISSOLUTION
OF POLITICS-ECONOMICS SO
THAT, IN EXCHANGE FOR,
SAY, ONE DAY'S WORK PER
YEAR, EACH PERSON GETS
PASSPORT-CREDIT-CARD (AC-
CESS TO WHAT GLOBAL-VIL-
LAGE-HUMAN-RACE HAS TO
OFFER).

One thing he said: "There is already enough of the unknown." Did he think of it then as spice or vitamin, additional at any rate to something not it, something known? Knowing, as we do, gravity doesn't act, what shall we consider that we know?

Invade areas where nothing's definite (areas—micro and macro—adjacent the one we know in). It won't sound like music—serial or electronic. It'll sound like what we hear when we're not hearing *music*, just hearing whatever wherever we happen to be. But to accomplish this our technological means must be constantly changing.

I asked him what a musical score is now.
He said that's a good question.
I said: Is it a fixed relationship of parts?
He said: Of course not; that would be insulting.

THEY SAID ONE THING INVOLVING SYMBOLS—LINEAR RELATION-SHIPS—WHICH MADE ME THINK THEY DIDN'T UNDERSTAND. BUT THEN THEY SAID SOMETHING ELSE —THAT THE SCHOOL'S DAYS OF BEING OPEN WOULD BE UNPRE-DICTABLY ARRANGED. THE RESULT WAS WE HAD A PLEASANT DAY TOGETHER.

Complaint: you open doors; what we want to know is which ones you close. (Doors I open close automatically after I go through.)

The thing that's so offensive about the series is the notion that it is the principle

from which all happenings flow (it would be perfectly acceptable for a series to enter

into a field situation). But the prediction of series equals harmony equals mind of

man (unchanged, used as obstacle, not as fluent component open at both ends)!

Privilege of connecting two things remains privilege of each individual (e.g.: *I: thirsty: drink a glass of water*); but this privilege isn't to be exercised publicly except in emergencies (there are no aesthetic emergencies).

PERMISSION GRANTED. BUT NOT TO DO WHATEVER YOU WANT.

(Fish) Species, separated and labeled, isn't what an aquarium is now. It's a large glass water-house with unidentified fish freely swimming. Observation—Discovery.

At present, it appears to be a series of components—a sound-system—but it is a series of *components*, not a *series* of components. Soon 'twill be done wirelessly; then it won't appear to be different than what it already essentially is: *not* a series of components.

It's no longer a question of people led by someone who assumes responsibility. It's as McLuhan says: a tribal situation. We need one another's help doing (food-gathering, art) what is to be done.

IT MUST BE DONE IN A WAY IT CANNOT BE TAUGHT (HE SIMPLY HANDED ME A SPECIMEN AND WAS GENEROUS ENOUGH TO SAY: IT IS EASY TO IDENTIFY. HE SAID NOTHING ELSE. I THEN NOTICED THE OPPOSITE LEAVES ARRANGED ALTERNATELY ON THE STEM AT RIGHT ANGLES). IT REMAINS TO BE SEEN WHETHER I'LL REMEMBER, HAVE TIME TO DIG.

Dealing with language (while waiting for something else than syntax) as though it's a sound-source that can be transformed into gibberish.

I have made two concert tours in Japan, one in 1962 with David Tudor, the other in 1964 with the Merce Cunningham Dance Company. Both of these visits were made possible by the Sogetsu Art Center, a lively organization which is part of the flower-arrangement school in Tokyo established by Sofu Teshigahara. It includes a studio for electronic music, a theatre for movies, concerts, and performances, halls for the exhibition of paintings and sculpture, and many offices where, at an instant's notice, tea, and even food, is served. The Sogetsu Art Center has many publications. For our tours elaborate programs were printed including texts. Written material in Japan is in great demand. The newspapers, magazines, and the radio constantly need it. In December of 1963 the Japanese Radio asked me to greet the music-lovers of Japan on the occasion of the New Year (and not to take more than a minute to do so). After some preliminary remarks, I wrote, "Music is music now if it is not interrupted by ambient sounds just as painting is painting now if it is not spoiled by the action of shadows. What is the crux of the matter as far as a listener is concerned? It is this: he has ears; let him use them.

HAPPY NEW EARS!

(Ears are only part of his body: I wish the whole of him and all of you, whether you love music or not, Happy New Year! This Year and All Years!)" The texts which follow were my responses to two other requests, one written in advance of a visit, the other written in the air while flying east to San Francisco. They were translated into Japanese and published somewhere inside or outside the Sogetsu Art Center.

———

Max Ernst, around 1950, speaking at the Arts Club on Eighth Street in New York City, said that significant changes in the arts formerly occurred every three hundred years, whereas now they take place every twenty minutes.

Such changes happen first in the arts which, like plants, are fixed to particular points in space: architecture, painting, and sculpture. They happen afterward in the performance arts, music and theatre, which require, as animals do, the passing of time for their realization.

In literature, as with the myxomycetes and similar organisms which are classified sometimes as plants and sometimes as animals, changes take place both early and late. This art, if it is understood as printed material, has the characteristics of

objects in space; but, understood as a performance, it takes on the aspects of processes in time.

I have for many years accepted, and I still do, the doctrine about Art, occidental and oriental, set forth by Ananda K. Coomaraswamy in his book *The Transformation of Nature in Art,* that the function of Art is to imitate Nature in her manner of operation. Our understanding of "her manner of operation" changes according to advances in the sciences. These advances in this century have brought the term "space-time" into our vocabulary. Thus, the distinctions made above between the space and the time arts are at present an oversimplification.

Observe that the enjoyment of a modern painting carries one's attention not to a center of interest but all over the canvas and not following any particular path. Each point on the canvas may be used as a beginning, continuing, or ending of one's observation of it. This is the case also with those works which are symmetrical, for then the observer's attention is made mobile by the rapidity with which he drops the problem of understanding structure. Whether or not a painting or sculpture lacks a center of interest may be determined by observing whether or not it is destroyed by the effects of shadows. (Intrusions of the environment are effects of time. But they are welcomed by a painting which makes no attempt to focus the observer's attention.) Observe also those works of painting, sculpture, and architecture which, employing transparent materials, become inseparable from their changing environments.

The tardiness of music with respect to the arts just mentioned is its good fortune. It is able to make deductions from their experiences and to combine these with necessarily different experiences which arise from its special nature. First of all, then, a composer at this moment frees his music of a single overwhelming climax. Seeking an interpenetration and non-obstruction of sounds, he renounces harmony and its effect of fusing sounds in a fixed relationship. Giving up the notion of *hauptstimme,* his "counterpoints" are superimpositions, events that are related to one another only because they take place at the same time. If he maintains in his work aspects of structure, they are symmetrical in character, canonic or enjoying an equal importance of parts, either those that are present at one instant, or those that succeed one another in time. His music is not interrupted by the sounds of the environment, and to make this a fact he either includes silences in his work or gives to his continuity the very nature of silence (absence of intention).

In addition, musicians, since they are several people rather than one person as a painter or sculptor is, are now able to be independent each from another. A

composer writes at this moment indeterminately. The performers are no longer his servants but are freemen. A composer writes parts but, leaving their relationship unfixed, he writes no score. Sound sources are at a multiplicity of points in space with respect to the audience so that each listener's experience is his own. The mobiles of modern sculpture come to mind, but the parts they have are not as free as those of a musical composition since they share a common suspension means and follow the law of gravity. In architecture, where labor is divided as it is in music, music's freedom is not yet to be observed. Pinned to the earth, a building well made does not fall apart. Perhaps, though, when the dreams of Buckminster Fuller become actualities, houses, for example, that are dropped from the air instead of bombs, architecture, through flexible means unfamiliar to us now, will initiate a wholly new series of changes in the arts.

Changes in music precede equivalent ones in theatre, and changes in theatre precede general changes in the lives of people. Theatre is obligatory eventually because it resembles life more closely than the other arts do, requiring for its appreciation the use of both eyes and ears, space and time. "An ear alone is not a being." Thus, more and more, we encounter works of art, visual or audible, which are not strictly speaking either paintings or music. In New York City they are called "happenings." Just as shadows no longer destroy paintings, nor ambient sounds music, so environmental activities do not ruin a happening. They rather add to the fun of it. The result, coming to the instance of daily life, is that our lives are not ruined by the interruptions that other people and things continually provide.

I have attempted briefly here to set forth a view of the arts which does not separate them from the rest of life, but rather confuses the difference between Art and Life, just as it diminishes the distinctions between space and time. Many of the ideas involved come from the Orient, particularly China and Japan. However, what with the printing press, the airplane, telegraphy, and nowadays Telstar, the distinctions between Occident and Orient are fast disappearing. We live in one world. Likewise the distinctions between self and other are being forgotten. Throughout the world people cooperate to effect an action. Hearing of anonymity, one can imagine the absence of competition.

Can anyone say how many artists will be born in the next twenty minutes? We are aware of the great changes taking place each instant in the numbers of people on this planet. And we know of the equally great changes in practicality— what, that is, through technology, people are able to do. Great numbers of men will bring about the future works of art. And these will go in more directions than

history records. We no longer have to lull ourselves expecting the advent of some one artist who will satisfy all our aesthetic needs. There will rather be an increase in the amount and kinds of art which will be both bewildering and productive of joy.

♏ ♏ ♏

Last April in Hawaii, I asked Tohru Takemitsu what Maki (his three-year-old daughter) thought of the United States. He said: She thinks it's another part of Japan. Visiting Hamada in Machiko, I expected there, off the beaten track, to see things specifically Japanese. Hamada showed pots, objects, and furniture from all over the world—Spain, Mexico, China, Arizona. The situation music finds itself in in the United States and Europe, it also finds itself in in Japan. We live in a global village (Buckminster Fuller, H. Marshall McLuhan). Maki is right.

One of the things we nowadays know is that something that happens (anything) can be experienced by means of technique (electronic) as some other (any other) thing (happening). For instance, people getting in and out of elevators and the elevators moving from one floor to another: this "information" can activate circuits that bring to our ears a concatenation of sounds (music). Perhaps you wouldn't agree that what you heard was music. But in that case another transformation had intervened: what you heard had set your mind to repeating the definitions of art and music that are found in out-of-date dictionaries. (Even if you didn't think it was music, you'd admit that you took it in through your ears, not through your eyes, nor did you feel it with your hands or walk around inside it. Perhaps you did walk around inside it: the architecturality of music is now a technical possibility and a poetic fact.)

If this elevator-originated music had been heard, what modern Japanese music would it have been? Who among the following would have made this possibility an actuality (a music which we will soon hear whether we happen to be in Tokyo, New York, Berlin, or Bombay)? Yori-aki Matsudaira? Yuji Takahashi? Joji Yuasa? Tohru Takemitsu? Takehisa Kosugi? Toshi Ichiyanagi?

Toshi Ichiyanagi. During my recent visit to Japan I listened to tape recordings of music by all the composers I mention except Kosugi. Kosugi's work I saw at Sogetsu Art Center. (His music is taking the clothes of theatre and wearing them in a way that redignifies both arts.) And in April at the East-West Center in Hawaii I was with Takemitsu. All these composers interest me, and more than European ones because they give me more freedom to do my own listening. They don't use sound to push me

where I don't want to listen. However, they all connect themselves (their ideas, their feelings, the accident that they're Japanese) with the sounds they make. Except Ichiyanagi. Ichiyanagi has found several efficient ways to free his music from the impediment of his imagination. In a piece called *Distance* he requires the performers to climb above the audience to a net from which they activate instruments which are placed below on the theatre floor. This physical separation brings about an unusual playing technique that brings the sounds together in the natural way they are together whether in the fields, in the streets, or in the homes and buildings. In a string quartet called *Nagaoka,* Ichiyanagi requires the players to bow where they usually finger and finger where they normally bow. This is miraculous, producing a music that does not make the air it is in any heavier than it already was. And with the assistance of Junosuke Okuyama (who if the Lord knew His business would be multiplied and placed in every electronic music studio in the world) Ichiyanagi has made a number of useful works: *Life Music, Mixture on Tinguely, Pratyahara.* These pieces (I heard only the first two recently) are as outrageous and interminable as Buddhist services and meditations. But like other unpleasant things and experiences, they are good for us. Why? Because, if we don't pamper ourselves but actually put up with the experience of them, we find our ears and our lives changing, not in a way that obliges us to go through Ichiyanagi (or Japan for that matter) to have our daily beauty but which fits us each moment (no matter where we live) to do our music ourselves. (I am speaking of nothing special, just an open ear and an open mind and the enjoyment of daily noises.)

In this changing musical world Japan is no less centrally placed than any other country. Having the composers and technical assistance it has, it is more fortunately populated than most.

Music and mushrooms: two words next to one another in many dictionaries. Where did he write *The Three-Penny Opera?* Now he's buried below the grass at the foot of High Tor. Once the season changes from summer to fall, given sufficient rain, or just the mysterious dampness that's in the earth, mushrooms grow there, carrying on, I am sure, his business of working with sounds. That we have no ears to hear the music the spores shot off from basidia make obliges us to busy ourselves microphonically.

While hunting morels with Alexander Smith in the woods near Ann Arbor, I mentioned having found quantities of *Lactarius deliciosus* in the woods in northern Vermont. He said, "Were the stipes viscid?" I said, "Yes, they were." He said, "It's not *deliciosus;* it's *thyinos.*" He went on to say that people go through their entire lives thinking that things are that when they are actually this, and that these mistakes are necessarily made with the very things with which they are the most familiar.

Once when I was in Ann Arbor with Alexander Smith, I said that one of the things I liked about botany was that it was free of the jealousies and selfish feelings that plague the arts, that I would for that reason, if for no other, given my life to live over again, be a botanist rather than a musician. He said, "That shows how little you know about botany." Later in the conversation I happened to mention the name of a mycologist connected with another Midwestern university. Incisively, Smith said, "Don't mention that man's name in my house."

• • •

There was an international conference of philosophers in Hawaii on the subject of Reality. For three days Daisetz Teitaro Suzuki said nothing. Finally the chairman turned to him and asked, "Dr. Suzuki, would you say this table around which we are sitting is real?" Suzuki raised his head and said Yes. The chairman asked in what sense Suzuki thought the table was real. Suzuki said, "In every sense."

• • •

The first time the mushroom class was given at the New School, many people signed up for it. The registrar was alarmed, telephoned me and asked, "Where shall we draw the line?" I said if more than forty people were involved it might be difficult. Something like that number registered for the course, but when the field trips actually took place, there were never more than twenty people in the woods. Sometimes attendance dropped to a mere dozen. I couldn't figure out what was happening. I forget who it was, but one day in the woods one of the lady students confessed that when she signed up for the course it was not with the intention of tramping through the woods near New York City, fungi or no fungi. She was interested in going to Europe. Some airplane company had advertised inexpensive round-trip fares purchasable only by adults enrolled in the New School. People had studied the catalogue as though it were a menu, looking for the cheapest course regardless of what was being taught. The lady who told me this had had a change of mind, or her particular flight had been postponed, I don't remember which. One way or another, she lost interest in Europe. Another, noticing fungi in Bavarian and Milanese markets, sent post cards.

• • •

When Colin McPhee found out that I was interested in mushrooms, he said, "If you find the morel next spring, call me up, even if you only find one. I'll drop everything, come out, and cook it." Spring came. I found two morels. I called Colin McPhee. He said, "You don't expect me, do you, to come all that way for two little mushrooms?"

• • •

Mr. Romanoff is sixty years old. Mr. Nearing is seventy years old. Mr. Romanoff's mother is eighty-five. On one of the mushroom field trips, a photographer came who had been sent by *The New York Times*. We took the Stony Brook trail. We had no sooner gotten started than the photographer busied himself taking pictures. Soon Mr. Romanoff was not to be seen. Mr. Nearing drew Lois Long aside and said, "Mr. Romanoff has had an accident to his pants. Would you find out whether one of the ladies has a safety pin?" Lois Long complied. A very small safety pin was found, and Lois Long gave it to Mr. Romanoff. He came back to the group. The safety pin, being so small, proved ineffective. Mr. Romanoff nevertheless stayed with the group, and, as the walk continued, the split in his pants progressed until it was complete, crotch to cuff. We stopped for lunch at a spring. Mr. Romanoff looked at his pants and said, "My mother will hear about this."

• • •

Mr. Romanoff says the Sunday field trips are better than going to church. However, one Sunday he said, "I can't come next Sunday because it's Rosh Hashana, and I've arranged with my mother that if I stay home on Rosh Hashana, I'll be able to come on Yom Kippur."

35

In April 1964 Michael O. Zahn of Milwaukee, Wisconsin, wrote asking what my view of Charles E. Ives and his music was. I replied, as below, in handwriting on stenographic notepaper, a supply of which I generally have around. I didn't keep a copy of this letter, but when Mr. Zahn wrote to thank me his pleasure was such that I asked him to send me a Xerox. He did.

Then in September 1965 Irving Glick, a producer for the Canadian Broadcasting Corporation who was making a documentary program about Ives, asked me to make a statement on the composer's influence and current relevance. I did this in the CBC New York studio. When it was played back, I was pleased with what I'd said, and so wrote to Mr. Glick asking for a transcript of the tape. When that arrived, I was not pleased at all: my remarks seemed awkward, not worth keeping around. Then I remembered a text in *Explorations in Communication,* a book edited by E. S. Carpenter and H. Marshall McLuhan. This text omitted punctuation, introducing space instead, giving the impression speech, not writing, does. In December of '66 I spent an hour with Keith Waldrop's class in poetry at Wesleyan University, and a general plan for speech presentation (in which uh's and mm's and other noises one involuntarily makes when he's forming his thoughts while speaking would be represented graphically, as would inflections and changes in volume) was developed with the aid of the students present.

I've made no attempt, below, to graph pitch, emphasis, or changes of timbre. Breathing is indicated by triangles; swallowing appears as a series of descending circles; scribbles represent the uh's and other noises, some of which are attached to the ends of words.

The way these statements are presented is an effect on me of the work of Marshall McLuhan who so dramatically has turned the attention of many to the influences of communication media on sense perceptions, and the work of Marcel Duchamp who just about fifty years ago called attention to the value of things to which value was not ordinarily attached, and who, on another CBC occasion, when he was asked by the interviewer what he was doing, said, "I breathe."

TWO STATEMENTS ON IVES

April 7, 1964

Dear Mr. Zahn:

Thank you for your letter. I think that the only published statement I have about Ives is the one on pages 70-71 in *Silence*. And this statement is probably not of service to you. Now that you have pointed it out (this omission in my writing) I intend to write something about Ives. If I do, soon, I will send it to you.

We become, I believe, aware of the past by what we do. What we do throws a light on the past. Thus, in the '30s and '40s when I was concerned with rhythmic structure I was not interested in Ives. But more recently because of my indeterminate and unstructured works, I am interested in Ives. This interest does not lead me to the analysis or study of his work. I simply mean that

were some of his music to be
performed in my neighborhood
I would grasp the opportunity
to hear it.

Off hand I think that Ives' relevance
increases as time goes on. (On pg. 71
I object to the Americana aspects
of his work, but in view of "pop
art" they are pertinent.) And now
that we have a music that doesn't
depend on European musical history,
Ives seems like the beginning of it.

I heard (just recently in San Francisco)
a recording of a piece by the young
composer Ramon Sender called
Desert Ambulance. It was for
tape and accordion solo. The end
of it was very thick in a
middle register — the sound of
many strings and accordion
clusters —; like a cable of

sound. It made me think of
the complexity of Ives and
the way one perceives something
in it. Does it emerge? Or
do we enter in? I rather
think it emerges in this case.
And that nowadays we would
tend toward doing it ourselves
(we are the listeners), that is,
we would enter in. The
difference is this: everybody
hears the same thing if it
emerges. Everybody hears what
he alone hears if he enters
in.

Better than I, James Tenney
could answer your questions.
He has been finding works of
Ives and bringing them to
performance. I believe you can
write to him care of Music
School, Yale University, New Haven

4/ Connecticut.

I don't so much admire the way Ives treated his music socially (separating it from his insurance business): it made his life too safe economically and it is in living dangerously economically that one shows "bravery" socially.

But his "contribution to American music" was in every sense: not only spiritual, but also concretely musical. Nowadays everything I hear by Ives delights me. However the opportunity to hear his work is rare. I might not enjoy it so much if it were less rare.

Sincerely,
John Cage

during April
c/o Music Dept.
Univ. of Hawaii,
Honolulu,
Hawaii

Stony Point, N.Y.

⊿ The subject comes up of the influence of Ives ⊿ on our present

music ⊿ I rather think that influence doesn't go A

B C that is to say from Ives to someone younger than Ives ⊿ to people still younger ⊿

but that rather we live in a ⊿ field situation ⊿ in which by our actions

by what we do ⊿ we are able to see what other people do ⊿ in a different light than we do ⊿

without our having done anything ⊿ What I mean to say is that the music we are writing now influences the way ⊿ in which

we ⊿ hear and appreciate the music of Ives ⊿ more than that the music of Ives influences us to

do what we do ⊿ In the thirties when I began to write music ⊿

& the principal choice was to be made by a young composer was between Schoenberg and Stravinsky and I chose Schoenberg

⊿ there was an auxiliary situation produced by Henry Cowell and the New Music Society and the New

Music Edition of which he was the editor ⊿ ⊿ that brought to the attention of young

musicians ⊿ the work of Varèse Ruggles and Ives ⊿ I was not so

interested in Ruggles though he was his music was chromatic as was Schoenberg's because I was already inter-

ested in Schoenberg ⊿ I was interested in Varèse because of the ⊿

inclusion of noises in his music ⊿ I was not interested in Ives ⊿

because of the inclusion in his music of aspects of American folk and

popular material ⊿ I was simply not able to hear it as something that interested me ⊿

However later in the fifties when I began to be involved in chance operations ⊿ and what

I call indeterminate music ⊿ that interest on my part brought it about that

I was able to approach Ives ⊿ in an entirely different one might say even opposite spirit from the

original way in which I approached him ⊿ though I must say that still

the American aspects of his music strike me as

endearing and touching and sentimental as they are ⊿ they strike me as the part of his work that is not basically

interesting ⊿ If one is going to have referential material like that ⊿ I would be happier ⊿ if it was global

in extent rather than specific to one country as is the referential material of Ives' music ⊿

However the things in his music which are interesting to me now because of my involvement in chance and indeterminacy

⊿ make him a ⊿ composer of music that I am always happy to

hear ⊿ One thing is that he knew ⊿ that if sound sources came from different

points in space ⊿ that that fact was in itself interesting ⊿ Nobody before him had thought about

this ⊿ being intent on grouping performing musicians together in a huddle as though they were playing football

rather than music ⊿ in order to bring about ⊿ the fusions of European harmony But

Ives knew through his experience of village bands in New England ⊿ walking

around them ⊿ that things sound differently if they had different positions ⊿

in space and that of course is extremely interesting in our contemporary music ⊿ Also the freedoms that he

⊿ gave to a performer saying Do this or do that according to your choice ⊿ is directly in line

41

with present ⟡ indeterminate music ⟡ ⟿ There are
two other things I would like to ⟡ point out that interest me
⟿ One is what I would like to call the mud of Ives
⟿ It's all the part that is not referential ⟿ Out of this
mud are complex ⟡ superimposition ⟿ ⟡
 lines that make a web in which we cannot clearly perceive anything that's what I mean by the mud ⟿ come ⟿
rising up as it were ⟿ these American tunes hymn tunes and what not that don't inter
est me ⟿ ⟿ In that mud ⟿
 before we get the referential material ⟿ ⟿ is the
 is if one is listening to it ⟿ the possibility of
 not knowing what's happening ⟿ And
more and more in this global electronic world that we are liv-
ing in ⟿ I think this experience of non-knowledge ⟿ is more useful and more
important to us ⟿ than the Renaissance notion ⟿ of knowing A B C
D E F what you were doing ⟿ And so ⟡ I regard that very very
highly But ⟿ more than that in Ives' work I regard I could almost say
supremely although I'm ⟿ averse to climaxes ⟿
⟿ I regard his ⟿ ⟡
understanding ⟡ I think ⟿ of inactivity and of silence ⟿
A little over a year ago I was in Hawaii ⟿ and I had the opportunity to read the essay ⟿ which he
wrote that follows his One Hundred and Thirteen ⟡ Songs ⟿ only one hundred and thirteen copies ⟡
were published originally ⟿ and ⟡ one of these fell into my hands and I
read the essay and in it ⟿ he ⟡
 sees ⟿ someone sitting on a porch ▷ in a rocking chair
smoking a pipe ⟿ looking out over the ⟿ ⟡ landscape which goes into the distance
⟿ and imagines that as that person who is anyone is
sitting there doing nothing ⟿ that he is hearing his own
symphony ⟿ This I think
is ⟡ ⟿ for all intents and purposes the goal
of music ⟿ I doubt whether we can find a higher goal namely ⟿ that art
and our involvement in it ⟿ will somehow introduce us to the very life that we are living ⟿
and that we will be able without scores without performers and so forth simply to sit still ⟿
to listen to the sounds which surround us ⟿ and hear them as music
⟿ At that point we won't need concert halls but we will be able nevertheless to enter con-
cert halls ⟿ and hear the music of Ives ⟿ I am sure even then ⟿ with gratitude

42

In March of 1965 I received from the *Kenyon Review* a copy of *Arnold Schoenberg Letters,* selected and edited by Erwin Stein, translated from the original German by Eithne Wilkins and Ernst Kaiser (St. Martin's Press, New York). I was informed that a book review by me would be welcome but that whether or not I wrote it I might keep the book. In May I visited Jasper Johns at Edisto Beach, spending much of my time writing the basis for the following text. I related all parts of the book (each letter, the jacket, the biographical notes, the table of contents, the several indexes) to the number 64, so that I could, by tossing coins following the *I-Ching* method of obtaining oracles, know which part of the book I was to discuss and how many words I was to use for that purpose.

Previously, in order to write an article, I had been using the materials of *Cartridge Music* (see the note preceding *Rhythm, Etc.*). This had produced texts which included spaces without words. The need for a text without such spaces had first arisen when I confronted the canvases of Jasper Johns which were completely painted; this need arose again as I read and reread the *Schoenberg Letters,* a book which is closely compacted in every sense.

The editors of the *Kenyon Review* published my text in the Summer 1965 issue, but with certain modifications which brought the review "more nearly into typographic conformity with the others."

Then, for the present circumstance, I removed those statements which dealt with other parts of the book than the letters themselves, and wrote (October 1966) new ones to take their places.

MOSAIC

Schoenberg's words are those italicized.
Quotations are remarks I recall he made when I was
studying analysis and counterpoint with him.

He became a Jew loyal to Jews. *I don't know whether such attempts to make things easier don't merely increase the difficulties.* Berg, Schoenberg, Webern. Another punctuation clarifies the matter: Berg-Schoenberg; Webern. *Now seriously . . . I . . . (. . . have only contempt for anyone who finds the slightest fault with anything I publish. One God.* The questions he asked his pupils had answers he already knew.

Answers his pupils gave didn't tally with his. Schoenberg needed to be sure of himself, so that, when leading others, he might be ahead. "You'll devote your life to music?" He thought of letters as improvisations. They were not compositions. Though he complained of the time his letters consumed, when he was *forced to rest* he wrote them. We're chucking this idea too (even though Schoenberg had it): that music enables one to live in a dream world removed from the situation one is actually in (and so the eyes of the music lovers, closed or reading scores—fortunate for them they're not crossing city streets). I explained to Stravinsky that studying with Schoenberg I had become a partisan: pro-Schoenberg, pro-chromaticism. Stravinsky: But I write chromatic music; my objection to Schoenberg's music: it isn't modern (it's like Brahms). Schoenberg pointed out others' mistakes; aware of his own, he corrected them. Criticism is unnecessary. *I disagree with almost everything.* Books he remembered were written by *opponents.* Musical conventions, complexity, yes—but let no objects and settings for operas puzzle his audiences. *... it is much more interesting to have one's portrait done by or to own a painting by a musician of my reputation than to be painted by some mere practitioner of painting whose name will be forgotten in 20 years, whereas even now* (he was thirty-five) *my name belongs to history. Our values.* Composition using twelve tones was in the Viennese air. Hauer and Schoenberg both picked it up. But differently. Simultaneously? *I empower you to publish this letter . . . ; but if . . . so, . . . in its entirety; not excerpted.* What with his wretched financial situation, asthma, anti-Semitic attacks from political quarters, lack of public recognition, etc., one's led (if not to agree) to listen when he says: *This earth is a vale of tears and not a place of entertainment.* Experiencing music not composers' names: at the Private Concerts Schoenberg organized, members listened, not told what they were hearing or who'd composed it. Believing that truth existed, he was interested in knowing what it was. Analyzing a single measure of Beethoven, Schoenberg became a magician (not rabbits out of a hat, but one musical idea after another: revelation). *Arnold Schoenberg.* What becomes evident (and we knew it anyway) is that unless one is a comedian (and Schoenberg wasn't, though he played tennis at least once with the Marx brothers) all's lost. One's intentions make life nearly unendurable. *A glass of brandy and . . . enjoyed it.* Righteous indignation. *It would be possible to*

establish a unified terminology and . . . relevant descriptions and definitions if one could begin by getting doctors to describe their own pains He wouldn't enter a house because Strang, who lived there, had a cold. His students worshipped him. So that when he said "My purpose in teaching you is to make it impossible for you to write music," his words seemed helpful rather than devastating. *Alban Berg.* Before acting, he examined all the possibilities; aged seventy-six he left the decisions to others. *Think it over, and if you find it works, then do it.* Troubled by asthma and needing 5000 marks *quickly,* he lists three unpublished works, praises two, and discusses in connection with the third his feelings regarding praise, finding self-praise, though *malodorous,* preferable to that bestowed by others. Sitting in the living-room after dinner, Schoenberg was talking. Some of the ladies, Mrs. Schoenberg among them, were knitting. Schoenberg insisted, as long as he was talking, that there be no further knitting. To him, being a real musician meant being literate and having an ear educated by European music. The twelve-tone method was intended to replace *the functional qualities of tonal harmony.* These *functional qualities* are structural: dividing wholes into parts. Methods make contiguities. Not having the means to make new structures (Hauer), nor the desire to renounce structure (process), Schoenberg made structures neoclassically. Two years before he died, Vienna honored Schoenberg right and left, granting him free entry into the city. This gave him *pride and joy, singular pleasure,* but reminded him too of his opponents, diminished though they were in number and power. His *Harmonielehre* begins: "This book I learned from my pupils." But: a teacher's sole reward, he said, was ascribing pupils' successes to himself. Anton Webern. *Ruthless honesty. For . . . all I want is to compose. Even the fact that I write so many letters is a very harmful deviation from this principle. And though any one who means well by me should certainly write to me as often as possible (for I'm always glad of that), it should be in such a way that I don't have to answer!* He said she should leave the room, that he would also, that those remaining would vote whether she might continue in the class. Leaving after her, he said, smiling, "Be sure you keep her." Aggressiveness. He was a self-made aristocrat. *I wonder what you'd say to the world in which I nearly die of disgust.* Becoming an American citizen didn't remove his *distaste for democracy and that sort of thing.* Of former times when a prince

stood as a protector before an artist, he writes: *The fairest, alas' bygone, days of art.*
Schoenberg treated his written sentences as though they were movies and he the
film editor of a magazine: awarding to most no question marks or exclamation
points at all, to others anywhere from one to four. He underlined passages (italics
in the printed versions). Typing, he sometimes shifted to capitals, not shifting back
until his point had been made. Schoenberg asked a student to play the piece on the
piano. She said it was too difficult for her. "You're a pianist?" She agreed. "Then
go to the piano." On the way, she said she would play slowly in order not to make
mistakes. He said, "Play at the proper tempo and do not make mistakes." She
began. He stopped her: "You're making mistakes!" She began again. He stopped
her: "You're not going fast enough!" After several tries, each of which he inter-
rupted, she burst into tears, explaining between sobs that she had been to the
dentist that morning and had had a tooth pulled out. Schoenberg: "Do you have
to go to the dentist in order to make mistakes?" He considered independence of
mind praiseworthy. When questioned about his own work: "That's none of your
business." He asked Dehmel to write the text for an oratorio, giving him the subject
in detail and *only one limitation: . . . 60 printed pages. As for living-quarters and
tennis, the fact is these two problems are for us very closely connected.* He wanted
to get home easily after playing. *It costs money, having to take a taxi: unless of
course one buys oneself a car!* He considered using marble as a wall covering.
Works were left unfinished: particularly *Moses and Aron* and *Die Jacobsleiter.* And
the school he envisaged for Israel was never established; those who'd issue from
it *must be truly priests of art, approaching art in the same spirit of consecration
as the priest approaches God's altar.* Task of Israeli musicians? To set the world
an example. He was capable of laying down the law. In counterpoint classes, the
laws he gave were no sooner followed than he demanded they be taken less
seriously. Liberties taken, he'd ask: Why don't you follow the rules? He kept his
students in a constant state of failure. He excused what he did, pointing out that he
had precedents (Beethoven, Mozart). Buckminister Fuller speaks of time-lags.
Devotion to Webern precluded devotion to Schoenberg. Accepting composition with
twelve notes meant paying no heed to the theories and works of Josef Matthias
Hauer. Plan: 1, Listen to Webern until you can't stand it; 2, Play Schoenberg's

music until you're sick to your stomach. Effective antidote: Any Hauer piece you can lay your ears on. . . . *you will . . . recall my declaring at the time that only if —— —— were chucked out of the committee could I consider having anything to do with this society. This was not done. . . . The society doesn't exist for me.* His view (music's not something we experience, but rather an idea we can have, the expression of which can never be perfect though we ought — for artistic and moral reasons — to bring it as close to perfection as possible) is former and foreign. At the age of seventy-two he wrote a charming letter to Dr. Perry Jones, president of the Los Angeles Tennis Organization, asking for advice about how to proceed with tennis experience for his daughter, fifteen, and his son, ten. Lessons, membership in a club? Invited as guest of honor to a party to be given two weeks thence, he refused (honored guests should be invited at least a month or six weeks in advance). To compose conscientiously didn't finish matters. A broadcast of the piece with two cuts was a violation of his rights. Sending one letter but getting no reply, he wrote again, threatening legal action. To Alban Berg: *I'd like to know too if I can do anything for you in America: always supposing that I should have the power, of course. For there's no knowing how disregarded, slighted, and without influence I may be there. I always thought it was I who originated the term 'emancipation of the dissonance.'* No time for time: having divided each 4/4 bar in half (conventions did what he had to do), he found there were too many accents. His pupils did not think him arrogant when, as often, he said, "With this material Bach did so-and-so; Beethoven did so-and-so; Schoenberg did so-and-so." His musical mind, that is, was blindingly brilliant. Like most other composers, Schoenberg had more or less constant money problems. The thought arises whether these are not the true subject of music. *Only one thing I should like to say at once: I would not let a new work have its first performance in Vienna. The fact is I am the only composer of any reputation at all whom the Philharmonic have not yet performed. And it may as well rest at that! Very busy with teaching.* Synonyms were not interchangeable: Schoenberg insisted on the right word. *We don't yet know whether we shall be in New York this winter. It's very expensive, and we can live on 2/5ths of the money in the South, and I can recuperate.* Several letters suggest Schoenberg felt closer to Berg and Kokoshka than to Webern and Kandinsky. The

other way around might have been more interesting. A little anonymity would have been somewhat refreshing. Schoenberg's letters exhibit his well-nigh absolute self-confidence — something he possessed early in life. Thinking of Lippold and Stockhausen, one runs to the common denominator: Germany. But Schoenberg was from Austria and not Aryan. He changed the books he read. Writing texts on miscellaneous papers, he carefully folded them back to a size less than that of the book and inserted them neatly with paste. Publish the thickened Busoni *Sketch!* Everything, he said, is repetition. A variation, that is, is a repetition, some things changed and others not. Eventually a "Portrait of Schoenberg" by Kokoshka is a self-portrait by Schoenberg, far-reaching, everything changed but the subject. *To observe, compare, define, describe, weigh, test, draw conclusions and use them. Though I still think Shostakovich is a great talent.* Turning musicologist, Satie, in one composition, refers the pianist to another piece which he never wrote. Reading a newspaper, Schoenberg noticed that Downes had altered the title of one of his works. He wrote, correcting the error. Ordinarily, he insisted on a large number of rehearsals, but when informed that he could have as many as necessary he set about diminishing their number. *Write soon, and don't be offended about this letter . . . Arnold Schoenberg.* For Schoenberg, publishers, unlike critics, were a necessary evil. It never occurred to him to do without them. It remained for Mrs. Schoenberg to terrorize the musical world, permitting no printing of unpublished works, instead providing the musical materials plus a bill for each performance. Stein: "Adler was a friend of Schoenberg's youth, his first teacher"; "(Schoenberg) was self-taught." Though U.C.L.A. could no longer use him (he was too old), others called upon him. The Burgomaster of Vienna summoned him back to Austria; Israel would have had him shape its Academy of Music. Too late. The great man was — it is true — on his last legs . . . *face to face with the difficulties, problems, and inherent terms of the given material. Schoenberg.* Having heard of a *"cutting conspiracy,"* Schoenberg explained that that would not shorten a work: it would still be a long piece that was *too short in various places (where it had been cut).* He apparently thought that once he had made something, it should remain fixed for all time. Rigor mortis. A teacher, he realized — what administrators don't — that students surpassing the average might do so in only one subject. Craftsmanship. Repeated

listening. To repeat: "To improve international affairs, the thing to do is to develop foreign trade." *Arnold Schoenberg.* Each student trembled, knowing Schoenberg's wit might at any moment hit in his direction. The story that goes around that he forbade laughter isn't true. *We're living 'under the sign of Traffic'* . . . *one has to move on!* His taste? Awestruck, students never asked: why the striped T-shirt? why green and yellow stripes? why such heavy furniture sent from Europe to California? why such furniture chosen in the first place? "He was a complex man. . . . He could be generous, aggressive, witty, sardonic, profound, courageous, charming, sympathetic and suspicious." His situation in America improved. The Juilliard School even offered him a teaching post. But his health required his living in the South (Los Angeles! ! ! !). Not so bad either: in the midst of the depression, movie composers paid him $50.00 per hour for private lessons. *My self-education.* He was depressed by criticism because there were no limitations to his sense of responsibility. Though his experience was space-time, his idea of unity was two-dimensional: vertical and horizontal. On paper. The twelve-note system, the U.C.L.A. Retirement System are different. How? The Schoenbergs (wife, three children) received $29.60 monthly. An afternoon series of Beethoven-Schoenberg string quartet recitals was arranged at U.C.L.A. Schoenberg: "Music should be played at night, not in the afternoon." Studying English, late in life, Schoenberg made a few mistakes, later becoming fluent. We'd all written fugues. He said he was pleased with what we'd done. We couldn't believe our ears, divided up his pleasure between us. First afraid *(each new person might be a Nazi),* later delighted and grateful: someone was interested in his art.

David Tudor and I took a taxi down town. He was going to Macy's; I was going on to West Broadway and Prince where I get my hair cut. After David Tudor got out, I began talking with the driver about the weather. The relative merits of the Old Farmers' Almanac and the newspapers came up. The driver said they were developing rockets that would raise the weather man's predictions from 50 to 55 per cent accuracy. I said I thought the Almanac starting from a consideration of planets and their movements, rather than from winds and theirs, got a better start since the X-quantities involved were not so physically close to the results being predicted. The driver said he'd had an operation some years before and that while his flesh was dead and numb, before the wound healed, he was able to predict weather changes by the pain he felt in the scar, that when the flesh lost its numbness and was, so to speak, back to normal, he could no longer know in advance anything about changes in weather.

This text was written on the highways while driving from an audience in Rochester, New York, to one in Philadelphia, Pennsylvania. Following the writing plan I had used for *Diary: Emma Lake,* I formulated in my mind while driving a statement having a given number of words. When it had jelled and I could repeat it, I drew up somewhere along the road, wrote it down, and then drove on. When I arrived in Philadelphia, the text was finished.

It was used as my opening statement on a panel, *The Changing Audience for the Changing Arts,* May 21, 1966, at the Waldorf Astoria Hotel in New York City for the Arts Councils of America, which later that year changed its name to Associated Council of the Arts. The others on the panel were William Alfred, Elizabeth Hardwick, Stanley Kauffmann, John H. MacFadyen, and Richard Schechner. My text was printed in *The Arts: Planning for Changes,* the title given to the published proceedings of the twelfth national conference of the ACA.

DIARY: AUDIENCE 1966

I. Are we an audience for computer art? The answer's not No; it's Yes. What we need is a computer that isn't labor-saving but which increases the work for us to do, that puns (this is McLuhan's idea) as well as Joyce revealing bridges (this is Brown's idea) where we thought there weren't any, turns us (my idea) not "on" but into artists. *Orthodox seating arrangement in synagogues.* Indians have known it for ages: life's a dance, a play, illusion. Lila. Maya. Twentieth-century art's opened our eyes. Now music's opened our ears. Theatre? Just notice what's around. (If what you want in India is an audience, Gita Sarabhai told me, all you need is one or two people.) II. He said: Listening to your music I find it provokes me. What should I do to enjoy it? Answer: There're many ways to help you. I'd give you a lift, for instance, if you were going in my direction, but the last thing I'd do would be to tell you how to use your own aesthetic faculties. (You see? We're unemployed. If not yet, "soon again 'twill be." We have nothing to do. So what shall we do? Sit in an audience? Write criticism? Be creative?) We used to have the artist up on a pedestal. Now he's no more extraordinary than we are. III. Notice audiences at high altitudes and audiences in northern countries tend to be attentive during performances while audiences at sea level or in warm countries voice their feelings whenever they have them. Are we, so to speak, going south in the way we

experience art? Audience participation? (Having nothing to do, we do it nonetheless; our biggest problem is finding scraps of time in which to get it done. Discovery. Awareness.) "Leave the beaten track. You'll see something never seen before." *After the first performance of my piece for twelve radios, Virgil Thomson said, "You can't do that sort of thing and expect people to pay for it."* Separation. IV. When our time was given to physical labor, we needed a stiff upper lip and back-bone. Now that we're changing our minds, intent on things invisible, inaudible, we have other spineless virtues: flexibility, fluency. Dreams, daily events, everything gets to and through us. (Art, if you want a definition of it, is criminal action. It conforms to no rules. Not even its own. Anyone who experiences a work of art is as guilty as the artist. It is not a question of sharing the guilt. Each one of us gets all of it.) They asked me about theatres in New York. I said we could use them. They should be small for the audiences, the performing areas large and spacious, equipped for television broadcast for those who prefer staying at home. There should be a café in connection having food and drink, no music, facilities for playing chess. V. What happened at Rochester? We'd no sooner begun playing than the audience began. Began what? Costumes. Food. Rolls of toilet paper projected in streamers from the balcony through the air. Programs, too, folded, then flown. Music, perambulations, conversations. Began festivities. *An audience can sit quietly or make noises. People can whisper, talk and even shout. An audience can sit still or it can get up and move around. People are people, not plants.* "Do you love the audience?" Certainly we do. We show it by getting out of their way. (Art and money are in this world together, and they need each other to keep on going. Perhaps they're both on their way out. Money'll become a credit card without a monthly bill. What'll art become? A family reunion? If so, let's have it with people in the round, each individual free to lend his attention wherever he will. Meeting house.) VI. After an Oriental decade, a Tibetan Bikku returned to Toronto to teach. He told me that were he to speak the truth his audience would drop to six. Instead he gives lectures transmitting not the spirit but the understandable letter. Two hundred people listen on each occasion, all of them deeply moved. (Art's a way we have for throwing out ideas—ones we've picked up in or out of our heads. What's marvelous is that as we throw them out—these ideas— they generate others, ones that weren't even in our heads to begin with.) Charles Ives had this idea: the audience is any one of us, just a human being. He sits in a rocking chair on a verandah. Looking out toward the mountains, he sees the setting sun and hears his own symphony: it's nothing but the sounds happening in the air around him.

Once one gets interested in world improvement, there is no stopping. I began the following text immediately after finishing the first one. I gave it a length approximately the same but slightly different. The notebooks in which I wrote it were with me wherever I went. I finished it early in September 1966 in Pontpoint (par Pont-Sainte-Maxence) north of Paris in the country home of John de Menil and in the room where Montesquieu, I was told, had also written and on a not too dissimilar subject. It was accepted by Maxine Groffsky for publication in the Spring 1967 issue of the *Paris Review*.

DIARY: HOW TO IMPROVE THE WORLD
(YOU WILL ONLY MAKE MATTERS WORSE)
CONTINUED 1966

XXX. The most, the best, we can do, we
believe (wanting to give evidence of
 love), is to get out of the way, leave
space around whomever or whatever it is.
But there is no space! Difference between
pennilessness now and pennilessness then:
now we've got unquestioned credit. *"In
the Beginning was the Word."* *Pupul Jayakar
 (straight from India), talking about
 computers, said: An explosion of the Word;
 communication without language! (We'll
 still speak: a) for practical reasons; b)
for the pleasure of it; c) to say what
should/shouldn't be done.)* Bird up and

 overhead. Friends we no longer see.
 Gone. Some died. **XXXI.** Mexico, India,
Canada (changing citizenship). *Electronic
 democracy (instantaneous voting on the*

part of anyone): no sheep. World
credit. Hearing my thoughts, he asked: Are
you a Marxist? Answer: I'm an
anarchist, same as you are when you're
telephoning, turning on/off the lights,
drinking water. Private prospect of
enlightenment's no longer sufficient. Not
just self- but social-realization. *Fuller*
spoke of Semantography, universal picture
language devised by C. K. Bliss, said
it was rich in nouns while what we
need's verbs. **Servant problem.** What's
what? (Russia, U.S.A.) Which is which? I
mentioned drugs. Kremen said the human
mind's interesting enough in the
non-toxic state. XXXII. Asked about
housing utility, Fuller pointed out
electrically-lit roadside telephone
booths, twenty-four hour use of
facilities. (How this came about escaped
our notice, no voting or purchase
involved. Bed, food, bath to be expected,
added to telephone or available elsewhere:
decentralization of living.) Up by
our bootstraps! Lost in two
different ways. There was also a fire to
put out. Alone (no one to disagree with).
Chess. Asked what he did, he said he'd
studied meteorology, passed examinations,
graduated, that weather's simple to
predict. (What had his teachers had in
mind?) "There's no reason for the
mistakes that are generally made."
XXXIII. Changes in aquariums: all the fish
in the same tank; no Latin
information. **Cross-Texas, eighty miles per**

53

 hour, radio rocks and rolls (now I
 listen): "If it's a game, I won't play
 it. **Don't just stand there.** **Tell me**
 what's, what's, what's, what's on
your mind." He registered as a
 conscientious objector. Drafted
anyway, he was put on a train going south.
 He escaped, was caught, spent a year in
service. Then, since he never cashed any
 of the checks they'd given him, he
 received an honorable discharge.
 (Russian chickens had diseased muscles.
 Chemical therapies failed. Suddenly,
 the chickens were healthy. The
 muscular tissues'd been reduced to
chaos, disorganized by electrical means.)
XXXIV. **Boddhisattva Doctrine: Enter**
 Nirvana only when all beings, sentient,
 non-sentient, are ready to do likewise.
Couldn't believe my eyes (stopping for
 lunch in Red Bud, Illinois): a single
 photograph of nature (mountains.
lake, island, forests) enlarged, printed
twice, once left to right, once right to
left, the two prints juxtaposed to form a
 single image, seam down the middle.
 Eugenics. Proposal: take facts of
 art seriously: try them in economics/
politics, giving up, that is, notions about
 balance (of power, of wealth),
 foreground, background. **They will kill**
 you, she said, with kindness. There's a
temptation to do nothing simply because
 there's so much to do that one doesn't
know where to begin. Begin anywhere. For
 instance, since electronics is at

the heart of the matter, establish a
global voltage, a single design for
plugs and jacks. Remove the need for
transformers and adaptors. Vary not the
connecting means but the things to be
connected. **XXXV.** Way's being found to
overcome problem inherent in painting and
sculpture (fact of object): laser
projection of three-dimensional images.
To remove object place your hand in thin
air behind it. What's interesting about
minds is they work differently.
What's interesting about one mind is that
it works in different ways. Hunting for
one thing, finding another. Gardens
that seem uncultivated: Tinguely's at
Soissy-sur-Ecole. I remember clams from the
Sound exhibited years ago in a Seattle
aquarium (near the Farmer's Market,
admission ten cents) : their movement,
their timing of it. They were a bed,
immobile, one on top of the other,
two feet deep in a tank of water, sand
on the bottom of the tank. We were told
to wait. **XXXVI.** Weather feels good.
Isn't. More rain is needed. Water.
He played two games, winning one, losing
the other. He was continually himself,
totally involved in each game, unmoved
by the outcome of either. What's the
nature of his teaching? For one
thing: devotion (practice gives evidence
of it). For another: not just
playing half the game but playing all of
it (having a view that includes that of
the opponent). Suddenly a clam rose to

55

the surface directly, remained there a
　　　　　moment, then descended slowly,
　　　　　leaf-like, tipping one way, then the
　　　other, arriving at the bottom to produce
　　　a disturbance, such that clam after clam
　　did likewise, sometimes several, sometimes
　　　　　many, sometimes not one at all,
　　producing a dance that completely
involved us.　　(Doing all that we needed to
　　　do.)　　XXXVII.　　Projects involving many
　　　　　people and many interruptions go well.
　　　　　Private concerns stumble along.　　*The*
fact their parents have separated doesn't
　　　　　disturb the children.　　*They go on*
　　looking at television.　　*How old should*
　　they be before they smoke marijuana?　　*No*
one seems to know.　　**Tolstoy: art properly**
　　　　　arouses religious emotion (conduces to
　　　　　brotherhood, all mankind, no
　　boundaries).　　Skinner: "Let us agree to
start with, that health is better than
　illness, wisdom better than ignorance,
　　　　　love better than hate, and productive
　energy better than neurotic sloth.　　*We*
　　invented machines in order to reduce our
　work.　　*Now that we have them we think we*
　　　should go on working (Committee of
　　　　eight on Automation, Economics and
　Employment considering whether U.S.
　　society should be geared for employment
　or unemployment voted six to two in favor
of employment).　　XXXVIII.　　"I breathe."
　　　　　Starvation.　　**There's no stopping.**　　The
　　garden's a bungalow.　　The sky's its
　　roof.　　Hedges form the rectangular rooms.
　　　　　Apple tree, admired, split as though

56

struck by lightning. Coincidence?

Branch of it's on the lawn like a

picture that's not hanging straight.

Flowers are withering. Gardener's on

vacation. Mud is on the windshield,

fallen branches wherever we go. Sky's

ready for launching of missiles. "He hit

me first." We're open-minded. Result:

idea leaving head that had it returns

transformed. Individual's thoughts become

social projects. "World's O.K. as

is": "Work to make the world O.K." Moksha

transformed is artha from which it was a

liberation. Spirit's materialized.

Kama? Walking along, it'll happen we touch

one another, falling immediately in love.

XXXIX. If a Utopia such as Skinner '48

described (Walden Two), doesn't

exist, why doesn't it? If it does,

why aren't we all in it? *What traitor*

thinks makes clear what nation's mind's

become. Pound's refrain: down with

usury. Lincoln: Unless next President

outlaws private banking, America in

hundred years'll be in worse situation

than it (Civil War) is. Rest of the

world's suffered surgery so it won't be

India. Indian standing by New Jersey

waterfall seeing the surface of the pool

below white with the suds of detergents,

jammed with beer cans, suggested

containers that one could eat. Different

flavors. Things that return to

nature. XL. To finance Union vs.

Confederacy, Lincoln authorized

private banking in the U.S.A. Credit

(conventionally 9/10ths of economic

power, actual money constituting the

remaining tenth) became the property

of bankers. The notion is that not

everyone'll want his deposit back at the

same time. Nine times as much as a banker

had was safely to be loaned for interest.

As the story goes: Dad ran away, came

to a ranch, was given a job irrigating (a

job that'd kept several men busy every

day all day long). He looked the land

over, made something, dug something (can't

remember which). No further work was

necessary. Seeing he had nothing to

do, they fired him. XLI. We're getting

rid of the habit we had of explaining

everything. Margaret Mead's idea re

metropolitan transportation (Duchamp had

same idea in 'twenties): private cars

parked at city limits; city cars used as

one uses carts in super-markets and

airports, abandoned at one's destination.

Police busy returning cars to parking

lots, getting them serviced or repaired

whenever necessary. **Basic Economic**

Security (Robert Theobald: Free Men and

Free Markets): everyone'll have what he

needs. Wanting things that are

scarce, he'll make them, find them,

get them (as long as the supply lasts)

in return for having done something

machines don't do. The mushrooms appeared

sooner even than I expected. *XLII. To*

know whether or not art is contemporary,

we no longer use aesthetic criteria (if

it's destroyed by shadows, spoiled by

ambient sounds); (assuming these) we
use social criteria: can include action on
the part of others.　　We'll take the mad
ones with us, and we know where we're
going.　　Even now, he told me, they sit at
　　　　　　　the crossroads in African villages
regenerating society.　　Mental hospitals:
　　　　　localization of a resource we've yet
to exploit.　　I visited an aging
anarchist.　　(He had the remaining copies of
Martin's Men Against the State.)　　He
introduced me to two Negro children he'd
　　　　　　　　adopted.　　After they went out to
play, he told me what trouble he'd had in
deciding finally to draw this line: No
jumping up and down on the beds.　　XLIII.

As he travels from one place to another,
he leaves things behind.　　**He needs help but**
　　no one knows where he is.　　*Don't know*
what to read, Love's Body or out-of-date
newspapers that are lying around.
　　　Everything we come across is to the
　　　point.　　**Living underground because**
there was no money.　　**Arizona land and air**
permitted making mounds, covering them with
　　cement, excavating to produce rooms,
　　providing these with skylights.　　**For**
　　anyone approaching, the community was
　　　　　　invisible.　　**Cacti, desert plants: the**
land seemed undisturbed.　　Quantity
　　　　　(abundance) changes what's vice,
what's virtue.　　Selfishness is out;
　　carelessness is in.　　(Waste's
　　　　characteristic.)　　"Don't be a
litterbug."　　"Keep North Carolina green."
　　　　Scratch the Ten Commandments.　　One of

59

the new ones: Thou Shalt Not Live

(in addition to birth control, control

of birth, euthanasia). What nature

did we now must do. **XLIV. Bad politics**

(Souvtchinsky) produce good art. But of

what use is good art? (Johns said he

could imagine a world without it and

that there was no reason to think it would

not be a better one.) **He had been**

trained as a singer. Gave up music for

cooking. Started a small restaurant,

busy three times a day instead of

theatrically once (even then not

everyday). Julian Beinart said that when,

being chauffered in South Africa, he

noticed Negro hitchhikers, tribesmen who

cover their bodies with a fly-attracting

grease, flies being considered the finest

ornament, he asked the chauffeur to pick

the people up, the chauffeur refused.

Chauffeur said the grease left in the

car would be nearly impossible to

remove: "You'd never get rid of the flies."

XLV. A meal without mushrooms is like a

day without rain. Raised as a

Methodist, I've never taken drugs.

When a physicist told me electrodes near

my ears would remove my sense of

balance or, were I flying through space

and the capsule was revolving, make me

think my balance was normal, I was

fascinated. Asking Duchamp why I accept

electronics, refusing chemistry, he said,

"It's not against the law." **George Herbert Mead's**

discussion of the religious attitude:

first one thinks of himself as one

of a family, later as part of a community,
 then as living in a city, citizen of such
 and such a country; finally, he feels
no limit to that of which he is a part.
 XLVI. The past? Fuller's answer:
Keep it. Times Square, for instance: cover
 it with a dome; put in tables, chairs,
 plastic carpeting. (Keep what remains
so it's there to be enjoyed, not just read
 about.) Chinese proceed differently,
 Häger reports. Revolting against
themselves, they send tradition-maintaining
 artists, actors, musicians off to
hard labor in distant places. Clean slate.
 After each war, industry offers new
 products for sale. The benefits from
the present conflicts (hot and cold, on
 earth, in space) will be enormous. No
organization, school, for instance, will be
 able to afford them. The only customer
 (not just rich but big enough to use
them) will be the globe itself. **XLVII.**
 All the garbage cans in West Germany are
 the same size. **They have lids designed so**
 that the only thing one has to do is
 place them at the back of the garbage
 truck. **The truck does the rest: picks**
 them up, turns them upside-down, opens
 the lid, receives the garbage,
 closes the lid, sets them back on the
 street right-side-up. After getting
the information from a small French
manual, I was glad to discover that
 Lactarius piperatus and *L. vellereus,*
 large white mushrooms growing
plentifully wherever I hunt, are indeed

excellent when grilled. Raw, these have a
 milk that burns the tongue and
 throat. Cooked, they're delicious.
Indigestion. XLVIII. How will one
 discipline himself? More than he needs
 of everything'll do it for him. *He*
told me one of the things he noticed among
the people who were using marijuana and LSD
 was that they didn't bother with the
conventions of greeting one another or
 saying good-by. Open and closed
communities (a botanical expression):
 disturbing the earth, men have opened
 it up. Seeds and spores in the air
 have a chance to land, to live. Laws
 we need to break: law forbidding stops
along the highways except for emergencies
 or at designated points; law prohibiting
 the picking of useful plants. XLIX.
Home begins outside. Shelter's inside.
 [Buckminster Fuller's *Profile of the*
Industrial Revolution. Technical
acquisition by science of ninety-two atomic
 elements accomplished in 1932. Same year
(John McHale comments) gold as a
 certificate of wealth was abandoned in
 the U.S.A.] *Examine the papers, the*
books, to see what ideas were had that
 could be, but weren't, put to use. *Not*
 only ideas but inventions that worked:
 Dad's dehydrator that worked
 electrostatically, separating refuse
 oil into dry chemicals, water that
could be drunk, oil of the highest grade,
 his means for preventing lightning.
Picturephone: limited commercial service

now provided between New York, Chicago, and
　　　Washington.　　Limitation: customers must
　　　be highly involved in business,
　　government and/or war.　　**L.**　　**Abundance.**
Officials checked to make certain we'd
paid the air-travel tax, didn't ask to see
our passports.　　*Marcel Duchamp.*
　　　". . . Valencia, cathedral—University.
　　Palma will be interesting again, then
　　Dardona and off to Milan and after which
　　　　the western coast of Yugoslavia & tour
　　　　(at southern end) of Grecian Islands
after which plane from Athens to New York.
　　　Many travelers,—going everywhere.
　　　　Love, Mom"　　More irritated by the
　　schedule than the work, he announced
he'd do all the dishwashing.　　Shortly the
　　　　others were helping.　　Sometimes he had
　　　　nothing to do.　　**Returning from**
　　　　Europe: "We're all looking forward
　　　　to the return of the W.P.A.　　**It's the**
only thing we ever had any talent for."
　　　　LI.　　**"Utopia for practical purposes."**
　　　Tall Jewish teenager just ahead of me,
his mother, wanting to go shopping,
　　　concerned whether he'd be able to file
　　　　his passport application without her
　　help.　　After several departures, always
　　coming back, she finally left the crowded
room.　　Discovering that he'd play chess, I
　　brought out my portable magnetic set.
　　Standing in line, we played two games,
　　　　leaving the second one unfinished.
　　　　The cows in India, not understanding
traffic lights, cross intersections
　　　　whenever they reach them.　　Motorists

never get angry. They wait patiently. The
 evening air's heavy with the odor of
burning cow-dung, fuel used for cooking.
Buffalo enterprise: manufacture of
 contraceptives for cows. Fewer cows:
 more food for the starving millions.
LII. Story Agam told: "I'm looking for a
key I lost over there." "Why not look,
 then, where you lost it?" "It's too
dark over there. I look for it here where
 there's light." **Television up-to-date,
 things televised aren't. Receiving
 set, appliances up-to-date, home
isn't. Architecture: "Environment control
facility", "dwelling advantage" (Fuller),
 "each progressive model obsolete . . .
materials scrapped, reprocessed", ("more
 with less") "instituting . . . world
 industry . . ." "Include . . . design of . . .
services, maintenance, parts inventories
 and transportation performances
required to make . . . service operable around
the world." (John McHale.) "Allowing any
 kind of living."** Weights, measures.
 Music having too many or not enough notes
 in it (Takahashi's preference). LIII.
 The father's a dope addict. The mother
 (two days ago—they came in white
coats, white car, using flashlights, asking,
 "Where's the mad woman?") was taken away
 in a straight-jacket. The children sleep
at home, playing and having their meals
 next door. (Perpetual motion.) **Removing
social controls to points where they
escape our notice.** Examine situations.
 Make decisions. Implement them. [I

asked Fuller whether he played chess. He
 said he used to, but that now he plays
 only one (the biggest) game. He does
this energetically, globally ("I have a
 strong constitution"), encouraging
 youth who've inherited from television,
 their "third parent," world
 consciousness. "They think 'world'. . .
 Theirs will be the most powerful and
constructive revolution in all history."]
*LIV. More we leave the land, the more
 productive it becomes.* **Technique for**
 changing society: education followed by
unemployment. Article by Avner Hovne on
 automation *(Impact of Science on*
 Society **15:1, Unesco publication).**
Continuity values giving way to flexibility
 values. Automation alters what's done and
 where we do it. You could always tell
 when she was about to go out of her
 mind. She would begin to speak the
truth. April '64: fifty-five global
 services. September '65: sixty-one
 global services. No one I speak to
 knows anything about them. I have no
 list, don't know what the number,
 August '66, is. Instead I read what
I find in bookstores, libraries, getting
 clues here and there. World Health.
World Food. Listened to Fuller on the
 'phone, heard him insist: "World—not
 international—Man." **LV. In**
 connection with space travel, the
 Russians, they say, have found a means
 to induce sleep electronically. In twenty
 or thirty minutes one can get as much

65

rest as eight or nine hours normally
provide. *Economics (money).* *Bernard*
Monnier said: Yes. *"It's a question of*
credit, entirely fictional,
conventional." *Asked whether it's*
finally a matter of personalities (not
masks but the feelings people give one
another), he again said: Yes. *"It's a*
question of one person having
confidence in another." **Mobility,**
immobility. **Artists never had enough**
time to do their work. **Their lives**
always ended before the completion of
their projects. **Leisure, present or**
future, is not a social problem.
Perhaps the fact we haven't gotten to
know one another makes us think that
people have nothing to do. LVI. Urgency.
Expression of "losing tempo" in chess.
Obligation to retreat, to move a piece
one's moved, to proceed in a way having
nothing to do with one's plan. Take
time, he says. Move, but only after
you're fully aware of all the
possibilities. X-quantities. Indian
philosophy and society at loggerheads:
Indian society limited to family;
family's defined as stopping at the
seventh relationship. Another
error, Japanese: the refusal to be formally
introduced (brings about
philanthropies one doesn't want to
practice). The property at Pontpoint.
Formality and informality mixed:
elegance without pretense (an unessential
difference between the front and

kitchen doors). One mistake: only the
servants have TV. At table we
converse. After coffee we play solitaire,
chess, now and then glancing at the
paintings and sculpture ("Everything's been
looked at"). Four P. M. we go
hunting for mushrooms. "Another part of
the forest." *LVII. Discussing her
travels, a lady mentioned she'd been
in Mallorca. When she was asked where
that was, she said she had no idea. "We
flew." (Sky's heavily clouded: grey,
even black, some white. There are patches
of blue.)* **Bureaucracy.** He got the
notion his ideas belonged to him. He
refused to disclose them, fearing someone
else would profit from them. He made
contracts no one cared to sign. *The
view that all's equal (equal rights) is not
different from the view that all's
unequal (unique). No likes or dislikes
implicit in either view.*
*Non-obstruction. Criticism becomes
design (one's faculties used before
rather than after something's done).
Dialogue. LVIII. (Music's made it
perfectly clear: we have all the time in
the world. What we used timidly to take
eight minutes to play we now extend
to an hour. People thinking we're
not occupied converse with us while we're
performing.)* Suzuki's lecture on Yu,
the principle of not-knowing, a
not-knowing never to become a knowing.
Toward the end he laughed gently,
without expressing any accomplishment, and

said, "Isn't it funny? I come all the

way from Japan to explain something to you

which of its nature is not to be

explained?" Composer, who no longer

arranges sounds in a piece, simply

facilitates an enterprise. Using a

telephone, he locates materials,

services, raises money to pay for

them. *LIX. Mother wrote to say: "Stay*

in Europe. Soak up as much beauty as you

possibly can." Cards punched for

insertion in telephones so we don't

have to remember numbers or spend

time dialing. Acceleration. *What shall we*

do with our emotions? ("Suffer them," I

hear her saying.) Having everything we

need, we'll nevertheless spend restless

nights awake with desire for pleasures we

imagine that never take place. Things

also happen gradually (one of New

Babylon's anarchists was elected a

member of Amsterdam's City Council).

We've the right, Fuller explains, to object

to slavery, segregation, etc. (the

problem of work is solved: machines

take the place of muscles); we've not yet

the right to object to war: first we must

design, then implement means for

making the world's resources the

possession of all men. LX. American

anarchist, 1900, admitting failure,

retired to the South of France. Dad's

airplane engine, 1918, flew to pieces

before it left the ground. Alloys

needed to contain the power were still

undiscovered. Discover dialectrics for

ultra-high voltages (global electrical

 networks). Change society so

differences are refreshing, nothing to do

 with possessions/power. Octavio and

 Marie-José (we'll meet again in

 Mexico). Narayana Menon had said,

"You'll like the Ambassador; he's a poet."

I asked Paz whether being a diplomat took

 too much time from his poetry. He said

it didn't. "There is no trade between the

 two countries. They are on the very

best of relations."

--

At Darmstadt when I wasn't involved with music, I was in the woods looking for mushrooms. One day while I was gathering some *Hypholomas* that were growing around a stump not far from the concert hall, a lady secretary from the *Ferienkurse für Neue Musik* came by and said, "After all, Nature is better than Art."

• • •

After an hour or so in the woods looking for mushrooms, Dad said, "Well, we can always go and buy some real ones."

• • •

Sometime after my father's death, I was talking with Mother. I suggested she take a trip West to visit the relatives. I said, "You'll have a good time." She was quick to reply. "Now, John, you know perfectly well that I've never enjoyed having a good time."

• • •

When the New York Philharmonic played my *Atlas Eclipticalis* with *Winter Music (Electronic Version)*, the audience more or less threw propriety to the winds. Many walked out. Others stayed to boo. On Sunday afternoon the lady sitting next to my mother was particularly violent. She disturbed everyone around her. When the performance ended, Mother turned to her and said, "I am the composer's mother." The lady said, "Good Heavens! Your son's music is magnificent! Would you tell him, please, how much I loved it?"

• • •

Franz Kline was about to have the first showing of his black and white paintings at the Egan Gallery. Realizing that his mother had never seen his paintings and that she would surely be interested in doing so, he arranged for her to come to New York for the opening. After she had been in the gallery for some time, she said, "Franz, I might have known you'd find the easy way."

• • •

In 1960 I received a letter from a university president giving me an appointment for the following academic year. I called Mother to tell her the good news. I said, "I'm to be a Fellow in the Center for Advanced Studies at Wesleyan University." Mother said, "Why are they always connecting you with the dance?" Then, after a pause, she added, "Do they know you're a Zen Buddhist?"

Had Marcel Duchamp not lived, it would have been necessary for someone exactly like him to live, to bring about, that is, the world as we begin to know and experience it. Having this view, I felt obliged to keep a worshipful distance, though I had met him in the early 'forties, and in the late 'forties had written music for his sequence in Hans Richter's film *Dreams that Money Can Buy*. When I was in Japan in 1962 Yoshiaki Tono asked me to write a text for the September 1963 issue of *Mizue,* a monthly review of the fine arts, which was to include the second part of an introduction to the method of Marcel Duchamp. I gave him the following notes. Then, fortunately, during the winter holidays of '65–'66, the Duchamps and I were often invited to the same parties. At one of these I marched up to Teeny Duchamp and asked her whether she thought Marcel would consider teaching me chess. She said she thought he would. Circumstances permitting, we have been together once or twice a week ever since, except for two weeks in Cadaqués when we were every day together. Remarks here and there in my second and third texts on world improvement were suggested by things he did or ideas he expressed on these occasions.

26 STATEMENTS RE DUCHAMP

History

The danger remains that he'll get out of the valise we put him in. So long as he remains locked up —

The rest of them were artists. Duchamp collects dust.

The check. The string he dropped. The Mona Lisa. The musical notes taken out of a hat. The glass. The toy shot-gun painting. The things he found. Therefore, everything seen—every object, that is, plus the process of looking at it—is a Duchamp.

Duchamp Mallarmé?

There are two versions of the ox-herding pictures. One concludes with the image of nothingness, the other with the image of a fat man, smiling, returning to the village bearing gifts. Nowadays we have only the second version. They call it neo-Dada. When I talked with M.D. two years ago he said he had been fifty years ahead of his time.

Duchamp showed the usefulness of addition (mustache). Rauschenberg showed the function of subtraction (De Kooning). Well, we look forward to multiplication and division. It is safe to assume that someone will learn trigonometry. Johns

Ichiyanagi Wolff
We have no further use for the functional, the beautiful, or for whether or not something is true. We have only time for conversation. The Lord help us to say something in reply that doesn't simply echo what our ears took in. Of course we can go off as we do in our corners and talk to ourselves.

There he is, rocking away in that chair, smoking his pipe, waiting for me to stop weeping. I still can't hear what he said then. Years later I saw him on MacDougall Street in the Village. He made a gesture I took to mean O.K.

"Tools that are no good require more skill."

A duchamp

Seems Pollock tried to do it—paint on glass. It was in a movie. There was an admission of failure. That wasn't the way to proceed. It's not a question of doing again what Duchamp already did. We must nowadays nevertheless at least be able to look through to what's beyond — as though we were in it looking out. What's more boring than Marcel Duchamp? I ask you. (I've books about his work but never bother to read them.) Busy as bees with nothing to do.
He requires that we know that being an artist isn't child's play: equivalent in difficulty — surely — to playing chess. Furthermore a work of our art is not ours alone but belongs also to the opponent who's there to the end.
Anarchy?

He simply found that object, gave it his name. What then did he do? He found that object, gave it his name. Identification. What then shall we do? Shall we call it by his name or by its name? It's not a question of names.

71

The air

We hesitate to ask the question because we do not want to hear the answer. Going about in silence.

One way to write music: study Duchamp.

Say it's not a Duchamp. Turn it over and it is.

Now that there's nothing to do, he does whatever anyone requires him to do: a magazine cover, an exhibition, a movie sequence, etc. ad infinitum. What did she tell me about him? That he gave himself except for two days a week (always the same days, Thursdays, Sundays)? That he's emotional? That he formed three important art collections? The phonograph

Theatre

--

Alan Watts gave a party that started in the afternoon, New Year's Eve, and lasted through the night and the following day. Except for about four hours which we spent napping we were never without food or drink. Alan Watts lived near Millbrook. His cooking was not only excellent but elaborate. There was, for instance, I forget just when, a meat pie in the shape of a large loaf of bread. Truffles ran through the meat, which had been wrapped first in crepes and then in the crust, in which had been inscribed in Sanskrit "Oм." Joseph Campbell, Jean Erdman, Mrs. Coomaraswamy, and I were the guests. Jean Erdman spent most of the time knitting. Alan Watts, Mrs. Coomaraswamy, and Joseph Campbell conversed brilliantly about the Orient, its mythologies, its arts, and its philosophies. Joseph Campbell was concerned at that time about the illustration of his Zimmer book, *Philosophies of India.* He was anxious to find a picture which would include certain and several symbols, and though he had searched his own library and several public ones, he was still looking for the right picture. I said, "Why don't you use the one in Jean Erdman's knitting book?" Joseph Campbell laughed because he knew I hadn't even seen the picture. Mrs. Coomaraswamy said, "Let me look at it." Jean Erdman stopped knitting and gave her the book. Mrs. Coomaraswamy began interpreting the picture, which was of a girl in a sweater standing in a landscape. Everything, it turned out, referred precisely to the subjects with which Joseph Campbell was concerned, including the number in the upper right-hand corner.

• • •

I was arguing with Mother. I turned to Dad. He spoke. "Son John, your mother is always right, even when she's wrong."

This article was first published in the Jewish Museum catalog of the work of Jasper Johns early in 1964. I began work on it in September 1963. I searched for a way of writing which would relate somehow to the canvases and personality of the painter. The absence of unpainted space in most of his work and, what seemed to me, an enigmatic aura of his personality produced a problem, one which I was determined to solve and which for five months occupied and fascinated me. As a matter of fact, it still does. Johns more than any other painter has provoked large numbers of people to the use of faculties they would not otherwise have employed. I needed help. I got this from Lois Long and Merce Cunningham, close friends of mine and of Jasper Johns. They gave this help first in conversation, second in patient reading and discussion of my writing as it proceeded.

After giving up plans for a text which involved elaborate use of chance operations with respect to type faces, size of type, superimpositions of type, collage of texts previously written about Johns by other critics, I settled on the plan of making use—as described in the note in this volume preceding *Rhythm Etc.*—of my *Cartridge Music*. However, I took the empty spaces which developed from that way of writing as spaces to be filled in with further writing. The paragraphs and paragraph signs resulted from chance operations.

Johns and Rauschenberg, Cunningham and Tudor have been and continue to be artists of deep significance for me. They have all brought about changes in my work. I do not know whether I will ever fulfill a project I've had now for several years: to make a correspondence between these four and the seasons: David Tudor would be spring; Johns, summer; Cunningham, fall; Robert Rauschenberg, winter (creation, preservation, destruction, quiescence). Such a project would involve me in extending the following text on Jasper Johns, so that it would be four times as long as it is, a length relative in my mind to summer and its quality of keeping things around.

JASPER JOHNS: STORIES AND IDEAS

Passages in italics are quotations from Jasper Johns
found in his notebooks and published statements.

On the porch at Edisto. Henry's records filling the air with Rock 'n' Roll. I said I couldn't understand what the singer was saying. Johns (laughing): That's because you don't listen.

Beginning with a flag that has no space around it, that has the same size as the painting, we see that it is not a painting *of* a flag. The roles are reversed: beginning with the flag, a painting was made. Beginning, that is, with structure, the division of the whole into parts corresponding to the parts of a flag, a painting was made which both obscures and clarifies the underlying structure. A precedent is in poetry, the sonnet: by means of language, caesurae, iambic pentameter, license and rhymes to obscure and clarify the grand division of the fourteen lines into eight and six. The sonnet and the United States flag during that period of history when there were forty-eight states? These are houses, Shakespeare in one, Johns in the other, each spending some of his time living. ¶ I thought he was doing three things (five things he was doing escaped my notice).

He keeps himself informed about what's going on particularly in the world of art. This is done by reading magazines, visiting galleries and studios, answering the telephone, conversing with friends. If a book is brought to his attention that he has reason to believe is interesting, he gets it and reads it (Wittgenstein, Nabokov, McLuhan). If it comes to his notice that someone else had one of his ideas before he did, he makes a mental or actual note not to proceed with his plan. (On the other hand, the casual remark of a friend can serve to change a painting essentially.) There are various ways to improve one's chess game. One is to take back a move when it becomes clear that it was a bad one. Another is to accept the consequences, devastating as they are. Johns chooses the latter even when the former is offered. Say he has a disagreement with others; he examines the situation and comes to a moral decision. He then proceeds, if to an impasse, to an impasse. When all else fails (and he has taken the precaution of being prepared in case it does), he makes a work of art devoid of complaint.

Sometimes I see it and then paint it. Other times I paint it and then see it. Both are impure situations, and I prefer neither.

Right conduct. He moved from objecting to not objecting. Things beneath other people to do are not that way for him. America. ¶ Walking with him in the garden of the Museum of Modern Art, she said, "Jasper, you must be from the Southern Aristocracy." He said, "No, Jane, I'm just trash." She replied, "It's hard to understand how anyone who's trash could be as nice as you are." Another lady, outraged by the beer cans that were exhibited in the gallery, said, "What are they

doing here?" When Johns explained that they were not beer cans but had taken him much time and effort to make, that if she examined them closely she would notice among other things fingerprints, that moreover she might also observe that they were not the same height (i.e. had not come off an assembly line), why, he asks, was she won over? Why does the information that someone has done something affect the judgment of another? Why cannot someone who is looking at something do his own work of looking? Why is language necessary when art so to speak already has it in it? "Any fool can tell that that's a broom." The clothes (conventions) are underneath. The painting is as naked as the day it was born. ¶ What did I say in Japan? That the Mona Lisa with mustache or just anything plus a signature equals adition, that the erased de Kooning is additive subtraction, that we may be confident that someone understands multiplication, division, calculus, trigonometry? Johns.

The cigars in Los Angeles that were Duchamp-signed and then smoked. Leaning back, his chair on two legs, smiling, Johns said: My beer cans have no beer in them. Coming forward, not smiling, with mercy and no judgment he said: I had trouble too; it seemed it might be a step backward. Whenever the telephone rings, asleep or awake he never hesitates to answer. ¶ *An object that tells of the loss, destruction, disappearance of objects. Does not speak of itself. Tells of others. Will it include them? Deluge.*

Why this palaver about structure? Particularly since he doesn't need to have any, involved as he is with process, knowing that the frame that will be put around the all that he makes will not make the environment invisible? Simply in order to make clear that these flags-numbers-letters-targets are not subjects? (That he has nothing to say about them proves that they are not subjects rather than that he as a human being is absent from them. He is present as a person who has noticed that *At every point in nature there is something to see.* And so: *My work contains similar possibilities for the changing focus of the eye.*) Structures, not subjects—if only that that will make us pause long enough in our headstrong passage through history to realize that Pop Art, if deducted from his work, represents a misunderstanding, if embarked upon as the next step after his, represents a non-sequitur. He is engaged with the endlessly changing ancient task: the imitation of nature in her manner of operation. The structures he uses give the dates and places (some less confined historically and geographically than others). They are the signature of anonymity.

When, dealing with operative nature he does so without structure, he sometimes introduces signs of humanity to intimate that we, not birds for instance, are part of the dialogue. Someone, that is, must have said Yes *(No)*, but since we are not now informed we answer the painting affirmatively. Finally, with nothing in it to grasp, the work is weather, an atmosphere that is heavy rather than light (something he knows and regrets); in oscillation with it we tend toward our ultimate place: zero, gray disinterest.

It does not enter his mind that he lives alone in the world. There are in fact all the others. I have seen him entering a room, head aloft, striding with determination, an extraordinary presence inappropriate to the circumstance: an ordinary dinner engagement in an upstairs restaurant. There were chairs and tables, not much room, and though he seemed to be somewhere else in a space utterly free of obstructions he bumped into nothing. Furthermore he reached the table where I was sitting and recognized me immediately. Another time he was working. He had found a printed map of the United States that represented only the boundaries between them. (It was not topographical nor were rivers or highways shown.) Over this he had ruled a geometry which he copied enlarged on a canvas. This done, freehand he copied the printed map, carefully preserving its proportions. Then with a change of tempo he began painting quickly, all at once as it were, here and there with the same brush, changing brushes and colors, and working everywhere at the same time rather than starting at one point, finishing it and going on to another. It seemed that he was going over the whole canvas accomplishing nothing, and, having done that, going over it again, and again incompletely. And so on and on. Every now and then using stencils he put in the name of a state or the abbreviation for it, but having done this represented in no sense an achievement, for as he continued working he often had to do again what he had already done. Something had happened which is to say something had not happened. And this necessitated the repetitions, Colorado, Colorado, Colorado, which were not the same being different colors in different places. I asked how many processes he was involved in. He concentrated to reply and speaking sincerely said: It is all one process.

Conversing in a room that had both painting and sculpture in it and knowing as he does that there is a difference between them, he suddenly laughed for he heard what he had just said (I am not a sculptor). I felt suddenly lost, and then speaking to me as though I were a jury he said: But I *am* a sculptor, am I not? This remark let me

find myself, but what I found myself in was an impenetrable jungle. There are evidently more persons in him than one. (A) having painted a picture gives it the title *Flag*. (B) having made a sculpture gives it the title *Painted Bronze*. (A) referring to (B)'s work says beer when to be in character he would say ale. (C) is not concerned with structure nor with sculpture *(Jubilee)*. (D) *(Painting with Two Balls)* is concerned with both. (E) has a plan: *Make something, a kind of object which as it changes or falls apart (dies as it were) or increases in its parts (grows as it were) offers no clue as to what its state or form or nature was at any previous time. Physical and Metaphysical Obstinacy. Could this be a useful object?* (F) experimentally inclined, among other ways of applying paint, stood on his head to make *Skin*. (G) sees objects in poetic interpenetration *(Fool's House)*. (H) stands sufficiently far away to see panoramically *(Diver)*. (I) records history [*Make Shirl Hendryx's shoe in sculpmetal with a mirror in the toe—to be used for looking up girl's dresses. High School Days. (There is no way to make this before 1955.)*]. (J) is concerned with language, (K) with culture sacramentally *(Tennyson)*. (L) makes plans not to be carried out. (M) asks: *Can a rubber face be stretched in such a way that some mirror will reorganize it into normal proportion?* (N) is a philosopher: "———" *differs from a* "———". (O) studies the family tree. (P) is not interested in working but only in playing games. (Q) encourages himself and others *to do more rather than less*. (R) destroys the works he finishes and is the cause of all the others. (S) made *The Critic Sees*. (T) ¶ Both Johns and we have other things to do (and in a multiplicity of directions), but that he let his work have the American flag as its structure keeps us conscious of that flag no matter what else we have in mind. How does the flag sit with us, we who don't give a hoot for Betsy Ross, who never think of tea as a cause for parties? (If anyone speaks of patriotism, it is nowadays global: our newspapers are internationally inclined.) The flag is nothing but The Stars and Stripes Forever. The stars are placed in the upper left hand corner of the field of stripes. But even though the whole thing is all off center it gives us the impression symmetry does, that nothing is in the wrong place. The flag is a paradox in broad daylight: proof that asymmetry is symmetry. That this information was given before so to speak the work was begun is a sign, if one needed one, of generosity which, alas, passeth understanding. Looking around his thoughts, he sees them in the room where he is. The clock doesn't always tell the same time. The dining room table in the dining room does. *We're not idiots*. Just as, answered, the telephone presents an unexpected though often recognized voice, so a table should speak, provoking, if not surprising, at least a variety of responses.

Eating is only one. The dining room table will not do. It is taken apart, stored, then sent to the south. Another, a loan not a possession, but having a history of many uses, is brought in. That it is round is its concern. It might have been square or rectangular. Its surface, however, stimulates the tendency to do something, in this case a process of bleaching and staining. And the chairs around it: the removal of varnish and the application of paint. The result is nothing special. It looks as though something had been tried and had been found to work: to have many uses, not focussing attention but letting attention focus itself.

He does not remember being born. His earliest memories concern living with his grandparents in Allendale, South Carolina. Later, in the same town, he lived with an aunt and uncle who had twins, a brother and sister. Then he went back to live with his grandparents. After the third grade in school he went to Columbia, which seemed like a big city, to live with his mother and stepfather. A year later, school finished, he went to a community on a lake called The Corner to stay with his Aunt Gladys. He thought it was for the summer but he stayed there for six years studying with his aunt who taught all the grades in one room, a school called Climax. The following year he finished high school living in Sumter with his mother and stepfather, two half-sisters and his half-brother. He went to college for a year and a half in Columbia where he lived alone. He made two visits during that period, one to his father, one to his mother. Leaving college he came to New York, studying in an art school for a little over six months. After applying for a scholarship, he was called into an office and it was explained that he could have the scholarship but only due to his circumstances since his work didn't merit it. He replied that if his work didn't merit it he would not accept it. Later, working in a bookstore on 57th Street, he went to see an exhibition at the Stable Gallery. Leo Steinberg seeing him asked if he was Michael Goldberg. He said: I am Jasper Johns. Steinberg said: That's strange; you look so familiar. Johns said: I once sold you a book. Clothes do not make him. Instead, his influence at rare and unexpected moments extends to his clothes, transforming their appearance. No mask fits his face. Elegance. ¶ He went to the kitchen, later said lunch was ready. Wild rice with Boleti. Duck in a cream sauce with Chanterelles. Salad. Hazelnut cake with Coffee.

The thermostats are fixed to the radiators but lead ineffectually to two bare wires. The Jaguar repaired and ready to run sits in a garage unused. It has been there since October. An electrician came to fix the thermostats but went away before his

work was finished and never returned. The application for the registration of the car has not been found. It is somewhere among the papers which are unfiled and in different places. For odd trips a car is rented. If it gets too hot, a window is opened. The freezer is full of books. The closet in the guest room is full of furniture. There is, and anyone knows there is, a mystery, but these are not the clues. *The relationship between the object and the event. Can they ② be separated? Is one a detail of the other? What is the meeting? Air?*

The situation must be Yes-and-No not either-or. *Avoid a polar situation.* A target is not a paradox. Ergo: when he painted it he did not use a circular canvas. ¶ How lucky to be alive the same time he is! It could have been otherwise. ¶ Conversation takes place whether the telephone rings or not and whether or not he is alone in the room. *(I'm believing painting to be language, . . .)* Once he does something, it doesn't just exist: it replies, calling from him another action. *If one takes delight in that kind of changing process one moves toward new recognitions (?), names, images.* The end is not in view; the method (the way one brush stroke follows another) is discursive. Pauses. Not in order through consideration to arrive at a conclusion. (Staying with him is astonishing: I know perfectly well that were I to say I was leaving he would have no objection, nor would he if I said I was not going.) A painting is not a record of what was said and what the replies were but the thick presence all at once of a naked self-obscuring body of history. All the time has been put in one (structured?) space. He is able, even anxious, to repair a painting once it is damaged. A change in the painting or even someone looking at it reopens the conversation. Conversation goes on faithful to time, not to the remarks that earlier occurred in it. Once when I visited him he was working on a painting called *Highway*. After looking at it I remarked that he had put the word right in the middle. When I left he painted over it so that the word, still there, is not legible. I had forgotten that this ever happened. He hasn't. ¶ *Three academic ideas which have been of interest to me are what a teacher of mine (speaking of Cézanne and cubism) called "the rotating point of view" (Larry Rivers recently pointed to a black rectangle, two or three feet away from where he had been looking in a painting, and said ". . . like there's something happening over there too."); Marcel Duchamp's suggestion "to reach the Impossibility of sufficient visual memory to transfer from one like object to another the memory imprint"; and Leonardo's idea . . . that the boundary of a body is neither a part of the enclosed body nor a part of the surrounding atmosphere.* ¶ A target needs something else. Anything in

fact will do to be its opposite. Even the space in the square in which it is centrally placed. This undivided seemingly left over area miraculously produces a duplex asymmetrical structure. Faces.

Make this and get it cast. (Painting with ruler and "gray.") Sculpt a folded flag and a stool. Make a target in bronze so that the circles can be turned to any relationship. All the numbers zero through nine. 0 through 9. Strip painting before tying it with rope (Painting with a rope). Do Not Combine the 4 Disappearances. A through Z. He didn't do this because it seemed like a jewel. (The individual letters disappear into a single object.) Perhaps there's a solution. *It moves. It moved. It was moved. It can, will, might move. It has been moved. It will be moved (can't have just it).*

Does he live in the same terror and confusion that we do? *The air must move in as well as out—no sadness, just disaster.* I remember the deadline they had: to put up a display, not in windows on a street but upstairs in a building for a company that was involved in sales and promotion. Needing some printing done they gave me the job to do it. Struggling with pens and india ink, arriving at nothing but failure, I gradually became hysterical. Johns rose to the occasion. Though he already had too much to do, he went to a store, found some mechanical device for facilitating lettering, used it successfully, did all the other necessary things connected with the work and in addition returned to me my personal dignity. Where had I put it? Where did he find it? That his work is beautiful is only one of its aspects. It is, as it were, not interior to it that it is seductive. We catch ourselves looking in another direction for fear of becoming jealous, closing our eyes for fear our walls will seem to be empty. Skulduggery.

Focus. Include one's looking. Include one's seeing. Include one's using. It and its use and its action. As it is, was, might be (each as a single tense, all as one). A = B. A is B. A represents B (do what I do, do what I say).

The demand for his work exceeds the supply. The information that he has stretched a canvas, if, that is, it was not already commissioned, produces a purchase. He conceives and executes an exclusive plan: the portfolios of lithographs. Two rows of numbers, 0 1 2 3 4 above, 5 6 7 8 9 below, the two rows forming a rectangle having ten equal parts; centered below this and separated by space is a single

number of greater size but in a smaller area. (The two rectangles are not equal: together they produce asymmetry.) Because there are ten different numerals, and because each single lithograph shows only one of them in the lower rectangle, there are ten different lithographs in each portfolio, one for each numeral. The edition is one of thirty sets: a third in different colors on white, ten in black on off-white, the rest in gray on natural linen. (All the papers have as watermark the artist's signature.) The working process employed two stones: a large one upon which the two structures appear, a smaller one having the inferior rectangle alone. As the work proceeded, due partly to things that happened outside his control, partly to his own acts, the stones passed through a graphic metamorphosis showing both utter and subtle changes. The smaller stone, given its own color or value (sometimes barely differentiated from the color or value given the larger one), appears on only a single lithograph of a given portfolio, on in fact that lithograph having the large number corresponding to the number of that portfolio. Beyond these three sets of ten, three portfolios exist *hors de commerce.* They alone show the total work, but each of them is unique, printed in the different inks on the different papers. The world he inhabits us in? One in which once again we must go to a particular place in order to see what there alone there is to see. The structure above is as unchanging as the thirteen stripes of our flag. The structure below changes with each number just as the number of stars changes with each change in history. (The paradox is not just in space but in time too: space-time.) The alphabets were arranged that way in a book. He derived from them his own similar arrangement of numbers. *Competition as definition of one kind of focus. Competition (?) for different kinds of focus. What prize? Price? Value? Quantity?* Given the title and date of one of his works, he sometimes can remember it only vaguely, other times not at all. ¶ He is a critic. No matter how inspired it may have been, he refuses another's leap to a conclusion if it reveals that what was to be done was not done. He is puzzled by a work that fails to make clear distinctions (e.g. between painting and sculpture). Shrugging his shoulders he smiles. Grimly determined he makes *The Critic Sees.* ¶ The more hurricanes the better, his house is insured. Compact, opaque, often highly colored, cryptocrystalline . . . He is Other for whom to have been born is captivity. Alone he accepts the stricture as a wild animal can. Gazed at, he is of necessity arrogant.

The charcoal *0 through 9* began with an undivided space. But it was not the beginning. It was analysis of a painting in progress that used superimposed numbers as structure. It was not the work he was working on.

History of art: a work that has no center of interest does the same thing that a symmetrical one does. Demonstration: what previously required two artists, Johns does alone and at the same time. ¶ I drove to his studio downtown. He was sitting looking at an unfinished painting (which is one of the ways he does his work): all the colors in profusion; the words red, yellow, and blue cut out of wood hinged vertically to the edges of two separately stretched canvases, the mirrored imprints of the letters legible on both; one letter not in wood but in neon; the wooden ones with magnets permitting fixing and changing the position of objects—a beer can, a coffee can, paint brushes, a knife, no fork or spoon, a chain, a squeegee, and the spool from a supply of solder. The next day uptown he was working on the gray numbers, the sculpmetal ones (*Overcome this module with visual virtuosity. Or Merce's foot? (Another kind of ruler.) Foreign colors and images.*). And the same day laboriously on the shoe with the mirror in the toe. We wonder whether, if chinaberry trees meant the same to us as they do to him (Spanish moss too, and the seashore and the flat land near it that makes him think the world is round, Negroes, the chigger-ridden forest and swamps that limit the cemeteries and playgrounds, the churches, the schools, his own house, in fact, all up on stilts against probable inundation, azaleas and oleanders, palm trees and mosquitoes, the advent of an outlandish bird in the oak outside the screened porch, the oak that has the swing with an automobile tire for sitting, the swing that needs repair (the ropes are frayed), the shark's teeth, the burrs in the sand on the way to the beach, the lefthanded and righthanded shells, and grits for breakfast)—well, we just wonder.

He told me that he was having a recurrence of them, that he had had them some years before, dreams in which the things he saw and that happened were indistinguishable from those of the day. I must have changed the subject for he told me nothing more. When I mentioned this to her, she told me what he had said: that going one day into the subway he had noticed a man selling pencils to two women— a man whose legs had been cut off, who moved about by means of a platform with wheels. That night Johns was that man, devising a system of ropes and pulleys by which to pull himself up so that he would be able to paint on the upper parts of the canvas which were otherwise out of his reach. He thought too of changing the position of the canvas, putting it flat on the floor. But a question arose: How could he move around without leaving the traces of his wheels in the paint? The cans of ale, *Flashlight,* the coffee can with brushes: these objects and the others were not found but were made. They were seen in some other light than that of day.

We no longer think of his works when we see around us the similar objects they might be thought to represent. Evidently these bronzes are here in the guise of works of art, but as we look at them we go out of our minds, transformed with respect to being.

All flowers delight him. He finds it more to the point that a plant after being green should send up a stalk and at its top burst into color than that he should prefer one to others of them. The highest priority is given, if he has one out of the ground, to putting a plant in the earth. Presented with bulbs from the south, impatient for them to bloom, he initiated a plan for a sped-up succession of seasons: putting them to freeze on the terrace and then in the warmth of an oven. Flowers, however, are not left to die in a garden. They are cut and as many varieties as are blooming are placed together in a fierce single arrangement, whether from the garden, the roadside, or the florist's: one of these, two of those, etc. (Do not be fooled: that he is a gardener does not exclude him from hunting; he told me of having found the blue Lactarius in the woods at Edisto.) Besides making paintings that have structures, he has made others that have none (*Jubilee* for instance). I mean that were two people to tell what the division of that rectangle is into parts they would tell two different things. The words for the colors and the fact that a word is not appropriately colored ("You are the only painter I know who can't tell one color from another"), these facts exercise our faculties but they do not divide the surface into parts. One sees in other words a map, all the boundaries of which have been obscured (there was in fact no map); or we could say one sees the field below the flag: the flag, formerly above, was taken away. Stupidly we think of abstract expressionism. But here we are free of struggle, gesture, and personal image. Looking closely helps, though the paint is applied so sensually that there is the danger of falling in love. We moderate each glance with a virtuous degree of blindness. ¶We do not know where we stand, nor will we, doubtless, ever. It is as though having come to the conclusion that going to sleep is a thing not to do, he tells us so that we too may stay awake, but before the words have left his lips, he leaves us in order that he himself may sleep. ("We imagine ourselves on a tightrope only to discover that we are safe on the ground. Caution is unnecessary." Nevertheless we tremble more violently than we did when we thought we were in danger.) When he returned to New York from the south, she asked him how it had been. He said: It was warm. There were no mosquitoes. You could even sit out in the yard. (I missed the polka dots in the area above the lower lefthand corner. Strange; because that's what I was

thinking about: the paintings *0 through 9* that are covered with polka dots.) Seeing her window over the kitchen sink, he said: That's what I want to have, a window over the kitchen sink so that I can look out to the terrace. She said: What you need is a door, so that you don't have to go to the front of the house and then all the way back on the outside again. But, he said, I don't want to go out, just look out. And then asked (imagining perhaps there was something he could learn from her to do): Do you go out? She admitted she didn't. They laughed. She pointed out the plant on the sill with last year's peppers on it and new blossoms but showing no signs of their becoming this year's peppers. He said: Maybe they need to be pollenated. And shortly with kleenex he was botanist, dusting and cross-dusting the flowers.

Take *Skin I, II, III, IV*. What a great difference there is between these and anything his works before or after could have led us to expect! As his generosity continues unabated, we waste the breath we have left muttering of inscrutability. Had he been selfish and singleminded it would have been a simple matter for anyone to say Thank You.

Even though in those Edisto woods you think you didn't get a tick or ticks, you probably did. The best thing to do is back at the house to take off your clothes, shaking them carefully over the bathtub. Then make a conscientious self-examination with a mirror if necessary. It would be silly too to stay out of the woods simply because the ticks are in them. Think of the mushrooms (Caesar's among them!) that would have been missed. Ticks removed, fresh clothes put on, something to drink, something to eat, you revive. There's scrabble and now chess to play and the chance to look at TV. *A Dead Man. Take a skull. Cover it with paint. Rub it against canvas. Skull against canvas.*

We have the impression that we're learning nothing, but as the years pass we recognize more and more mushrooms and we find that the names that go with them begin to stick in our heads. Furthermore, we're still alive. However, we must be cautious. Guy Nearing sometimes says that all mushroom experts die from mushroom poisoning. Donald Malcomb finds the dangers of lion hunting largely imaginary, those of mushroom hunting perfectly real.

One day I telephoned Miró. He was in a New York hotel about to leave for Europe. Our conversation was in French and I had never met him. I asked him to make a gift of a painting to the Cunningham Dance Foundation, explaining that this gift would make possible a European tour on the part of the dancers. (I knew that Miró had seen the 1964 performances of Cunningham and his Company at the Théâtre de l'Est Parisien and that he had been enthusiastic.) Miró asked me to write him a letter. I did. He replied generously, not only promising a gift but proposing performances in Spain for which he would make a poster. In further correspondence with Jacques Dupin, the poet and author of a book on Miró's work, a project developed for a publication to be made by the Fondation Maeght in Paris. It would include gravures by Miró, my *Variations VI* in all of its stages, a text by me written after our meeting (which took place early in August 1966 at Saint-Paul-de-Vence), and further gravures by Miró after he'd seen my manuscripts. I was afraid he would not like my work but fortunately this was not the case. He found it interesting and proposed using the notations (which are on transparent plastic sheets and which can be in any relationship) to make his own particular arrangement of them. Before sitting down to write, I read Miró's book, *Je travaille comme un jardinier*. I also read a number of texts about him. His work, of course, as for many living nowadays, is so familiar as to be part of who one is. I decided I would attempt to avoid mentioning what others consistently do: his relation to the earth. I had recourse to *I-Ching* operations, determining thereby that my text would have eight statements and that these would have, in order, twenty-nine, sixty-two, forty, seven, thirty-five, twenty-three, forty-seven, and fifty-eight words. I then suggested that, since Miró's relation to the earth was not being mentioned, my statements be super-imposed on maps of places where Miró had lived and worked. This suggestion was accepted but is not followed in the present printing. I wrote the text in September 1966 while visiting the Duchamps in Cadaqués.

MIRÓ IN THE THIRD PERSON: 8 STATEMENTS

Words in italics are from Miró's writings;
quotations are remarks he made in conversation.

Then they said: We will kill you. They'd already placed the rope around his neck. What next but fear? (Forgive them? People mean what they say, what they do.)

Expressing in one word what it was he had always been insisting upon, he said: Anima. A few days later when I repeated the word to him, he looked puzzled; he didn't seem to understand what I was saying. I told Duchamp about this. Duchamp became quite emphatic: Miró doesn't speak Latin; he must have said (not pronouncing the g): Un image.

This is the way: looking out over the sea where his island is. "I do this with all my heart." Way to do what? Catalunya. He becomes an Arabian chessplayer. (Visiting another, one visits him. Maps. Pun to King Four.)

Space. Even when close, there is distance.

Going to the North Pole? Then take Miró with you. "It seems to me I've known you all my life." The war. Unknown paintings. A night spent in laughter: omelet that fell on the floor.

The signs are complete (ready to become anything other than they are). Fire. We see no changes, not yet knowing how to forget.

"You open doors." He knows, I'm sure, they're automatic, closing the moment one passes through. A gardener, he's also a hunter, even when sleeping: earth disturbed, is receptive to whatever there is in the air: they told me he wanted to know, to see what was happening.

To plug in the amplifier, I turn the corner. He's looking at a Giacometti. Alone (he's) not alone. Shells that have the bass clef on them remind me of music. Ballet. What will it be? *I'm the first to be surprised. The simplest things give me ideas.* Anonymous blindness: four of us playing chess; three were making mistakes.

--

Doris Dennison had been born Doris Suckling. That was why she changed her name. Her step-brother, Peter, on the other hand, took the name she discarded. Peter Suckling had been born Peter Perfect.

• • •

I once had a job washing dishes in the Blue Bird Tea Room in Carmel, California. I worked twelve hours a day in the kitchen. I washed all the dishes and pots and pans, scrubbed the floor, washed the vegetables, crates of spinach for instance; and if the owner came along and found me resting, she sent me out to the back yard to chop up wood. She paid me a dollar a day. One day I noticed that some famous concert pianist was coming to town to give a recital, and I decided to finish my work as quickly as possible in order to get to the concert without missing too much of it. I did this. As luck would have it, my seat was next to that of the lady who owned the Blue Bird Tea Room, my employer. I said, "Good evening." She looked the other way, whispered to her daughter. They both got up and left the hall.

• • •

A mother and son visited the Seattle Art Museum. Several rooms were devoted to the work of Morris Graves. When they came to one in which all of the paintings were black, the mother, placing a hand across her son's eyes, said, "Come, dear, mother doesn't want you to see these things."

Among the letters I don't throw away when I go through my letters with the intention of throwing away as many as possible are those sent to me by Nam June Paik. We met in Darmstadt in 1958. Most of his letters are self-sufficient. They require no replies. However, one day Paik wrote to say that the Galeria Bonino in New York City was going to present his electronic art as its Exhibition No. 16 (23rd November – 11th December, 1965) and then went on to ask whether I'd write a text for the catalog, adding, "Your writing will be as attractive as , , , , , , , , , , , , say, , , , , , , 'Jackline Kennedy's endorsement to Mayor Lindsay' , , , , , , ,". I found this thought somewhat unsettling but it was in character. Shortly I was on the telephone telling Paik (whose work, conversation, performances, daily-doings never cease by turn to amaze, delight, shock, and sometimes terrify me) I'd do what he wanted. I wrote the following text. It was printed by the Bonino Gallery together with photographs of Paik's *Robot–K456* and his electronic alterations of television images. Also included were a biographical statement, documentation of his performances and exhibitions, and a list of his publications.

NAM JUNE PAIK: A DIARY

Passages in italics are quotations
from Nam June Paik found in his
letters and printed statements.

I. What is this thing called Art? TV? (Everything at once, no matter when/where we are?) On videocorder Paik records Pope—*validity or raison d'être for society*—making an electronic fact event. The film. Korean, we put ourselves easily in your shoes, composed, as you are, of nervousness and conscience. Guiltless, why would we have erected our antennae? (We needed to experience unequivocally what we had practiced refusing.) Are we glued to it? Nein. The question's whether it works. It's no game: it brings us circle from graves we're in (spots of light and sound in the air we breathe). II. Five year guaranty on your Paik TV? Is that what you want? And since it's art, which art is it? Change your mind or change your receiver (your receiver is your mind). Enjoy the commercials, that is to say, while you still have them. Global village: they're not here to stay. I replied things were funny

even though I didn't set out to make them so. A year or so later he left the room. The audience, terrorized, didn't budge. No one spoke. The telephone rang. "It was Paik calling to say the performance is finished." III. When I told Paik (don't say Peek, Poke or Puke) and Kosugi about the Cree Indians of central Saskatchewan, Paik asked: Are they like us? His shoes came off my feet, but, a moment later, glancing down, I noticed they were on again. His preoccupation with sex, violence, humor, criticism *(it is comic or sin to say I am the first to have thrown a egg— etc . . .):* but the Robot's shit is white in shapes suggesting vitamins, deodorants and the droppings of deer; the penis is the shadow of a finger; the vagina that of a whale. IV. *Danger Music No. 1 for Dick Higgins: Creep into the VAGINA of a living WHALE!* In other words, as Higgins has remarked (*Postface*, pg. 61), there is no danger. Nevertheless, we worry. Art and TV are no longer two different things. They're equally tedious. The geometry of the one's devitalized the other *(find out what kind of bad habits you have)*; TV's vibrating field's shaken our arts to pieces. No use to pick them up. Get with it: *Someday artists will work with capacitors, resistors & semi-conductors as they work today with brushes, violins and junk.* V. European music made a crucial mistake: the separation of composition performance and listening. Color TV likewise: red, green, blue. But both must be made real (oriental): fact of non-separation. Otherwise, when we turn it on, it won't go on. Ultimately, certainly, it will be on continuously as it invisibly, inaudibly already is. Paik is working on it *(I look back with a bitter grin . . . the desperate struggle . . .)*. Bathtub. "It's always this way with Paik before performances." The seeming impossibility of getting ready to begin. Wires and more wires. Antique sets used not as junk but required to come alive not as they did formerly but, poor things, according to a new trick. Considerate, he asks us to leave. VI. Like TV, he's here to stay (though his view is larger: *TV will dominate 50 years and will gone). What comes next? In 1970, play moonlight sonate on the moon.* Humanity. He is a criminal who converses (cf. Duchamp). Technology, optical art, music, physics, philosophy. Image of utter collapse. *Think again.* Circa 1959–1960: *My new composition is now 1 minutes. (For Prof. Fortner). The Title will be either "Rondo Allegro", or "Allegro Moderato", or only "Allegretto". Which is more beautiful? I use here: Colour Projector. Film 2–3 screens. Strip tease. boxer. hen (alive). 6 years girl. light-piano. motorcycle and of course sounds. one TV. // "whole art" in the meaning of Mr. R. Wagner.*

Eleven composers who had written music for the dance (of whom I was one) were invited by Selma Jeanne Cohen in 1962 to write for the sixteenth number of *Dance Perspectives,* the issue which was called *composer/choreographer.* In order to stimulate our thoughts, Miss Cohen gave us quotations from established figures in the field. I was given these:

> It is essential to keep the ear sensitive, but also to remember that the dance is an independent art, subject to laws of its own which can lead the choreographer to movements not really indicated in the score at all . . . to movements set above the sound on the basis of emotional timing. —*Doris Humphrey*

> I am not a creator of time. I like to be subordinated to it. Only a musician is a creator of time. . . . The music is first. I couldn't move without the music. I couldn't move without a reason and the reason is music. My muscles only move when time comes in. —*George Balanchine*

The text I contributed follows. It was published in 1963 with only part of the statement by Balanchine. My title and Doris Humphrey's remarks were omitted. The spaces which appear below between some of the sections of text were also omitted. Quotations with which I was unfamiliar were introduced in the margins printed in red. They were by George Bernard Shaw and Lincoln Kirstein. I liked the one by Kirstein: "It can't hurt a composer to know something about dancing."

WHERE DO WE GO FROM HERE?

Does dance depend? Or is it independent? Questions that seem political. They arose in an aesthetic situation. What's to be said? People and sounds interpenetrate.

We thought that sounds took place in time. We see they're vibratory movements of particles in air. Each one, setting out from its point in space, gets to all its arrivals from a single departure. Thoughts about time drop off like dead skin. Dance takes place with one foot in the grave. "Dance or I'll shoot"—each time the

curtain goes up. Laws seem petty: they've not sacrificed tangible concerns and returns. What are the Arts? Offerings beyond the law within the limits of practicality. Practicality — read the newspapers — is changing.[1] Years ago it was a question of

1. They ask when we speak: What are you trying to say? However, being told about the weather, we get ideas about the next step to be taken. It's those old statements that are so disconcerting — the ones we've memorized. A story, if it's new, could be refreshing. But when I try to remember her, I think of no stories. True, we sat together by appointment in Carnegie Tavern, but there was a twisted quality in her mind that made everything else seem absent. Nothing like conversation took place. I only begged and she refused. The other one had a chance but didn't take it and like most of us rabbits wherever he sees room he moves in. The third who might have been one of the two — well, we tried. We started a rumor that he had resigned. The young ones. Do they have to do it all over again?

which one came first — the music or the dance. We'd tried the music first, so it seemed only reasonable to start things roundabout, putting the dance first. Later, when thinking-caps were used, it became evident that underneath both music and dance was a common support: time. This partial truth would have been hard to come by for a choreographer, due partly to the multiplicity of elements in the theatrical dance and due for the rest to the fact that analytical thought in the field of the dance was centered formerly on the problem of notation. Music, on the other hand, was, in those days, a relatively simple art: a succession of pitches in a measured space of time. Moving out toward the complexity introduced by twentieth-century noise, music's materials became more numerous. Not just pitch and time, but timbre and amplitude too: four basic elements. One could think about music on the fingers of one hand without putting his thumb in it. All one had to do was establish a time-structure.[2] Neither music nor dance would be first: both would go

2. We are poorer than we ever were because now we know how to spend money. And not just the studios for dance and the laboratories for music but the halls and the theatres. Renovation won't do. We need to start from scratch. The whole question of theatre has to be answered afresh. A building for people and things (sounds and lights) that will work in this day and age will be costly. Anything else is money down the drain. (Unless, of course, you are rich by virtue of not yet having begun. In that case, any place will do and you can simply use the ones that don't cost anything. However, I stopped the car when I saw him coming from the mailbox and said I'd decided that things had to be electronic even in India. He agreed.) Yet — say we managed to get such a theatre built — what good would it do if it were fixed to one place like an ancient monument?

along in the same boat. Circumstances — a time, a place — would bring them together. We've paid our bills and the President's been elected. Now we get down to business. Business is: to space-time our arts. That's one way of putting it. A job that will keep us in a state of not knowing the answers. The time-structures we made fell apart: our need faded, so that aesthetic terms have totally disappeared from our language. Balance, harmony, counterpoint, form. (When he was told that the addition of a little purple would give an impression of distance, he burst out laughing.) We resemble the anarchists of the Ohio in the first part of the last century: too busy working to talk, or, if we talk, simply passing the time of day. What brought about the falling apart of time-structures? The introduction, perhaps, of space into our concept of time? At least we sense that as music remaining time becomes space its elements become legion, and analytical thinking's no help. Musicians need now some way to work that doesn't deal with parameters: otherwise, like convicts, musicians'll be obliged come good weather to stay indoors.

The Lord knows we get instruction constantly. It's just that we fail to listen and forget to look. Offhand I'd say I remember, but if I started out to repeat these words, I'd slip for sure. Fingers don't use the same time-lengths legs do. It's the difference between two and ten. Is this the mistake of American ballet? That it goes too fast, stumbling over its torso? (Following in the footsteps of something that has no feet?) Instruction is on the land[3] and in the air, both for music and for dance.

3. He wrote to say among other things that Art was to be abandoned. I didn't answer. But I have this to say: I don't believe it. The situation we're in is unique: 1) population-explosion leading to many more ways of dancing and making music; 2) interpenetration of the world's peoples; 3) science and technology. These latter lead like the first to many more ways so that we become Imagination personified. Awake we seem to be dreaming. There is nothing un-American about this according to a book I recently read. It is a conversation on the grand scale even if it takes the shape of soliloquy. How is it that they chatter about communication but do not heed the meaning of what they do? Take melody and accompaniment or even a four-voice counterpoint with one voice as *hauptstimme*. What is the meaning? It is unbelievable that as many as do what they do mean what they do. They cannot possibly be as backward as they act. What's wrong? The Educational System? The Government? The chain stores? Madison Avenue? The H-bomb? Wall Street? The critics? The churches? The unions? The American Medical Association? Television?

Breathing and walking and managing to empty the head sufficiently to notice what there is to see and hear in the theatre we happen to be living in. There's not much more to say, or rather no space nor time to say it in.

The circumstances under which we met (he just telephoned) were these: a Philharmonic concert that included a work by Webern. We both walked out not wishing to hear what followed, shook hands and exchanged names. Later, examined scores and brought new friends to one another. There was a misunderstanding, but music changed, not only ours but that of others. The result is that if we were to meet again under similar circumstances, the music would have to be something other than Webern; otherwise we would not bother to get up and go out.

Blindly in love. That alone should be a warning as to what to take as basis. As for the other, beware, as they say, of mistaking the finger for the moon when you're pointing at it.

We're no longer satisfied with flooding the air with sound from a public-address system. We insist upon something more luminous and transparent so that sounds will arise at any point in the space bringing about the surprises we encounter when we walk in the woods or down the city streets. Thus music is becoming a dance in its own right and has, of course, new notations. There is the possibility, in fact the fact, of its having no notation at all. (This is no reference to improvisation. As it was, it's still a question of fulfilling obligations.) What we took for truth was just a part of it, but one could have spent a lifetime stupefied!

There is a first step *sine qua non:* Devotion. This is what dance technique signifies. Say discipline or self-renunciation. These are lessons one takes not in order to throw them away. But to enable what they are to infuse anarchic action. Flying from the nest, no other bird's wings will do. When we all shout together they still do not hear us even though they're nearby.

In 1952 I was invited to speak at the Juilliard School of Music—not by the Director but by the students. They were having a series of meetings and students from other music schools were also attending. My lecture was in four parts, in all of which I applied processes of collage and fragmentation to texts which I had written earlier. There was in addition some new material. While I was lecturing, David Tudor performed a number of pieces at the piano, compositions by Morton Feldman, Christian Wolff, and myself. To coordinate our program, we used chronometers. I began the first part at 0′ 00″, the second at 12′ 10″, the third at 24′ 20″, the fourth at 36′ 30″. David Tudor's program was made without my knowing anything about it in advance. I had written my text in four columns to facilitate a rhythmic reading and to measure the silences. I read each line across the page from left to right, not down the columns in sequence. I tried to avoid an artificial manner which might have resulted from my being too strictly faithful to the position of the words on the page. I used the rhythmic freedoms one uses in everyday speech.

While the lecture was being given, Feldman was sitting on the stage. Both of us answered questions put to us afterward. When neither of us could think what to say in response to some angry "question," Henry Cowell, who was present in the audience with his wife Sydney, put in a word for us, for which we were very grateful. Afterward as we tried to get through the halls to reach the room where punch was being served, students, surrounding us, continued their arguments. Cowell was always right beside us.

JUILLIARD LECTURE

1

In the course of a	lecture last winter on	Zen Buddhism,	Dr. Suzuki said
:	"Before studying	Zen,	men are men and
mountains are	mountains	.	While studying Zen
things	be-come confused	:	one doesn't know ex-
actly what is	what and which is	which	.
After studying Zen,		men are men and	mountains are mountains

 After the lecture
.”
the question was asked : “Dr. Suzuki
, what is the difference between men are men and
mountains are mountains before studying Zen and
men are men and mountains are mountains after studying Zen
?” Suzuki answered :

“Just the same , only somewhat as though you
had your feet a little off the ground.”

 Now, before studying
music, men are men and sounds are sounds.

 While studying
music things aren’t clear . After studying
music men are men and sounds are sounds. That is to say:
At the beginning, one can hear a sound and tell immediately
that it isn’t a human being or something to look at
; it is high or low —

 has a certain timbre and loudness,
lasts a certain length of time and one can hear it. One then decides
whether he en–joys it or not , and gradually de–
velops a set of likes and dislikes .
 While studying music
things get a little confused . Sounds are no
longer just sounds, but are letters: A, B, C, D, E, F,
G. Sharps and flats. Two of them, four or even five
octaves apart are called by the same letter .

If a sound is unfortunate enough to not have a letter or

if it seems to be too complex, it is tossed out of the system

on the grounds: it's a noise or unmusical .

The priveleged tones that remain are arranged in

modes or scales or nowadays rows, and an abstract

process begins called composition . That is, a

composer uses the sounds to express an idea or a

feeling or an integration of these .

In the case of a musical idea , one is told that the

sounds themselves are no longer of consequence ;

what 'count' are their re–lationships. And yet these re–

lationships are generally quite simple :

a canon is like children playing follow the leader .

A fugue is a more complicated game ; but it can

be broken up by a single sound : say, from a fire engine's siren

, or from the horn of a boat passing by .

The most that can be accomplished by no matter

what musical idea is to show how intelligent the composer was

who had it ; and the easiest way to ascertain

what the musical idea was is to get yourself in

such a state of confusion that you think that a

sound is not something to hear but rather something to

look at . In the case of a

musical feeling , a–gain the sounds are unim–

portant , what counts is expression . But the

most that can be accomplished by the musical ex–pression of feeling is

to show how e–motional the composer was who had it

. If anyone wants to get a feeling of how emotional a

composer proved himself to be, he has to confuse himself to the same

final extent that the composer did and imagine that sounds are not sounds at all

but are Beethoven and that men are not men but are sounds .

Any child will tell us : this is simply not the case.

A man is a man and a sound is a sound.

To realize this , one has to put a stop to studying music

. That is to say, one has to stop all the thinking that

separates music from living . There is all the

time in the world for studying music , but
for living there is scarcely any time at all . For
living takes place each instant and that instant
is always changing. The wisest thing to do
is to open one's ears immediately and hear a sound
suddenly be–fore one's thinking has a chance to
turn it into something logical, abstract, or symbolical
. Sounds are sounds and men are men,
but now our feet are a little off the ground.
Perhaps this will make understandable a statement made by
Blythe in his book Haiku. "The highest re–
sponsibility of the artist is to hide beauty." Now
, for a moment let's consider what are the important questions
, and what is that greater earnestness that is required
. The important question is what is it that is not just
beautiful but also ugly, not just good, but also evil , not just
true, but also an illusion. I remember now that Feldman spoke
of shadows. He said that the sounds were not sounds but shadows.
They are obviously sounds; that's why they are shadows; every something
is an echo of nothing . Life goes on very much like a piece by Morton Feldman
. Someone may ob–ject that the sounds that happened were
not interesting. Let him. Next time he hears the piece
—

 The nothing that goes on is what Feldman speaks of
when he speaks of being sub–merged in silence. The
acceptance of death is the source of all life. So that
listening to this music one takes as a spring–board the first
sound that comes a–long; the first something springs us into nothing and
out of that nothing a–rises the next something; etc. like an alter–
nating current. Not one sound fears the silence that ex–tinguishes it. And
no silence exists that is not pregnant with sound.

Someone said the other day :

We bake a cake and it turns out that the sugar was not
sugar but salt I no sooner start to work
than the telephone rings .

II

II

from any other leaf even of the same tree .
If it were the same as another leaf it would be a coincidence
from which each leaf would be free be–cause of its own
unique po–sition in space. Uniqueness ,
having a particular suchness , is extremely close

to being here and now. And I imagine that as contemporary music goes on changing in the way that I am changing it what will be done is to more and more completely liberate sounds from abstract ideas about them and more and more ex-actly to let them be physically, uniquely, themselves . This means for me: knowing more and more not what I think a sound is, but what it actually is in all of its a–coustical details and then letting this sound exist, itself, changing in a changing sonorous environment .

They are with respect to counterpoint, melody, harmony, rhythm, and any other musical methods, pointless. They are in-deed with–out purpose but in their purposelessness expressing life itself which centers out from them , in every direction. Silence surrounds many of the sounds so that they ex–ist in space unimpeded by one another and yet inter–penetrating one another for the reason that Feldman has done nothing to keep them from being themselves . He is not troubled a-bout continuity for he knows that any sound can follow any other. His works on music paper are not essentially different from those on graph for when he writes the notes and note values he does so directly and unhesitatingly , not involved with the idea of making a construction of a logical nature . His work re-minds me of a poem by Emily Dickinson : In insecurity to lie is joy's in–suring quality . And I'm also reminded of part of a sermon by Meister Eckhart . But with con-temporary music there is no time to do anything like classifying. All you can do is suddenly listen , in the same way that when you catch cold all you can do is suddenly sneeze .

Unfortunately,　　　European thinking　　has brought it　　　a–bout　　　　that
actual　　　things　　　that happen such as suddenly listening or　　　suddenly sneezing are not
considered　　　profound.

　　　　　　　　　　　　There　　is　　no　　communication and　　nothing　　　　be–
ing said.　　　　　　　Then why,　　　　　　was the next question,　　Why —
When it is actually　　contemporary,　　　we have no time to　　make that
separation (which pro–tects us from living)　and　　　　so　　contemporary　music
is not　　so　　much　art　as it is life　　and　　anyone making　it　　　no sooner
finishes　　one　　of　it　　than he begins　making　another　　just　　as　　people
keep on　　washing　dishes, brushing their　teeth, getting sleepy　and so on. Very fre–
quently no one knows　that contemporary　music is or could be art.　He　　　simply
thinks　　it　　was　irritating.　　　　　Irritating one way or　another, that is to
say,　　　　　　　　keeping　us　from　ossifying.　　　　　To conclude:
Christian Wolff　　　is　　　　　an–other composer　　who is　　changing
contemporary　music　.　　　　　　　I remember one day　hearing　him　play
a piano piece　　　of　his that　　had　silences in it.　It　was　　a　pleasant
day　　and　　the　windows　were　open.　　　　　Naturally,　　in the
course　　of the　piece,　　noises of　traffic,　　　sounds　　　from
boats' horns,　　　children　　playing　in the hall,　　could all　　be
heard,　and some of　them　　more　easily　　　than the　sounds　that　were
coming　from the　piano.　　　So much so　that a friend
who had　been　trying　with great　difficulty　　　to　hear　the　music
asked　　at　　the　end if Christian　would　play　it　over again
after　　　he'd　closed the windows　　　　　　　　Christian said
he'd be glad　　to　play the piece　a–gain, but that　　it　wasn't　urgently
necessary　since　the piece　　had　been played　and the　sounds　　　that
had accidentally　occurred while　it　was being played　were　　in　　no
sense an interruption　.　　　　　The windows　of　　his　music　were open —
"not wondering"　to　quote Meister　Eckhart, "Am　I　right　　or
doing something wrong ?"　One of　the　ones　who　is　changing it　　is
Morton Feldman　　.

Feldman writes his music sometimes on music paper and other times on graph. In a series of pieces called *Projections,* written on graph paper, he indicates only high, middle, and low in reference to pitch. A player is free at the instant of playing to play any note in the register indicated

It acts in such a way that one can 'hear through' a piece of music just as one can see through some modern buildings or see through a wire sculpture by Richard Lippold or the glass of Marcel Duchamp

— in his ear where he will find a metal ball , to toss it on the road in front of them , so that, as the horse goes on to say, we may be led by it. This, too, giving himself and his quest up to the aimless rolling of a metal ball, the hero, un—

questioningly does. They proceed thus , by chance,
by no will of their own, passing safely through many
perilous situ–ations. At the end of the journey , when
success is almost in view , the horse, to whom the
hero now knows he is most utterly indebted, asks the hero to kill him
. This causes some hesitation on the hero's part but
he finally acquiesces, and Lo, and be–hold, the horse
turns into a Prince, who, except for the acquiescence of
the hero would have had to remain a miserable
shaggy nag. I have noticed something else about
Christian Wolff's music ;

III

As we go along , who knows ? an i-
dea may occur in this talk .
I have no idea whether one will , or
not. If one does, let it. Regard it as something
seen momentarily , as though from a
window while traveling , if across Kansas
, then, of course, Kansas .
Arizona is more interesting. To accept
whatever comes , re-gardless of the consequences
, is to be unafraid or to be
full of that love which comes from a sense of at-
oneness with whatever. This goes to explain what Feldman means
when he says that he is associated with all of the sounds and so
can foresee what will happen , even though he has not
written the particular notes down as other composers do .
When a composer feels a re-sponsibility to make, rather than
accept, he e-liminates from the area of possibility all those events
that do not suggest the at that point in time vogue of profundity, for he takes
himself seriously, wishes to be considered great, and he thereby diminishes
his love and in-creases his fear and concern about what people will
think . There are many
serious problems confronting such an indi-vidual, but at
any moment destruction may come suddenly and then what happens
is fresher. How different this form sense is from
that which is bound up with memory, themes and
secondary themes, their struggle, their development, the climax,
the recapitulation, which is the belief that one may own one's own home
, but actually, unlike the snail , we carry our

homes within us which enables us to
fly , or to stay , to enjoy
each. But beware of that which is breath–takingly beautiful
.

Our poetry now is the realization that we possess
nothing . Anything therefore
is a delight (since we do not possess it) and thus
need not fear its loss. We need not destroy the past;
it is gone. At any moment it might reappear and seem to be and
be the present . Would it be a repetition?
Only if we thought we owned it, but since we don't, it is free and
so are we . Most anybody knows
about the future and how un–certain
it is . What I am calling
poetry is often called content. I myself have
called it form. It is the continuity of a piece of music.

Continuity, today, when it is necessary , is a
demonstration of dis–interestedness ; that is,
it is a proof that our delight lies in not pos–sessing anything
. Each moment presents what happens

.

 I derived the method I use
for writing music by tossing coins from the method used in the
Book of Changes for obtaining oracles. The method itself
is fairly complicated to describe and I shall not do
that now. If you are interested you can read
a detailed des–cription of it that will appear in the forthcoming
issue of *Trans /formations* . Suffice it to say that
tables are arranged re–ferring to tempi, the number
of superimpositions , that is to say, number of things that can go on at
once, sounds and silences, durations, loudnesses and accents.
At a given instant half of the tables are mobile and
half of them immobile. Mobile means: if that ele–
ment is tossed, it acts, but disappears .

 We are still at the point where most musicians are
clinging to the complicated, torn–up, competitive remnants of
tradition, and furthermore, a tradition that is neither
significant nor insignificant nor good nor bad but simply
poetry as I need it .
If there were a part of life dark enough to keep out of it a light from art

I would want to be in that darkness, fumbling around, if necessary, but
alive and I rather think one can dispense with all that fol-
derol; — no one loses nothing because nothing is se-curely possessed
. And I think I agree, but I have a very serious
question to ask you: How do you need to
cautiously pro-ceed in dualistic terms ?

In another
series of graphed works called *Intersections*, this freedom
with regard to pitch is ex-tended to include duration
. That is, just as a pedestrian
may cross a talk when you have something to say,
precisely because of the words which keep making us say in the
way which the words need to stick to and not in the Way
which we need for living. For instance: someone said:
Art should come from overhead . There was a social
calendar and hours for breakfast , but one day I saw a
cardinal , and the same day heard a woodpecker.
I also met Meister Eckhart: Earth has no es-cape from
heaven . Flee she up or flee she down,
heaven still invades her, energizing her, fructifying her,
whether for her weal or for her woe. A modern
Cuban composer, Caturla, earned his living as a judge. A
man he sentenced to life imprisonment escaped from prison and
murdered Caturla not where it is within us , but
like an empty glass into which
at any moment anything may be
poured , just something, finitely something,
or even to be able to drink a glass of water
. Unless some other
idea crops up a-bout it, that is all I have to say about structure

. What is that? We are the oldest at
having our air–way of knowing nowness
. It makes the silence in our music and the space
in spite of himself in everything. Now he knows he becomes the same
. H. C. E. Each one of us is thinking his
own thoughts, his own experience and each experience is different and
each experience is changing and while we are thinking, but
since we don't, it is free and so are we. Some people say
that is all very well, but it won't work for us.
As far as any–body else is con–cerned it's only pathetic.
A pupil once said to me: I understand what you say about
Beethoven (echo of nothing) that he is nothing but a roll of
toilet paper or a–bout a work of Art.
However, contemplation alone will not put the intervals, the
sevenths, the seconds, the tritone and the fourth and
civilization . One needs critics, connoisseurs,
judgments, authoritative ones . I have nothing against
the twelve–tone row which, of course, is changing, but
important questions cannot be decided
in this way . They require greater earnestness
. I must say
I still feel this way but something else is happening
. I begin to hear the old sounds
, the ones I had thought so freely at all of them that
they all re–ferred to the here and the now, but generally
by means of symbols so that frequently
if one had a responsibility to believe in them one got caught in
the opposite. Making that particular continuity that excludes all
Progress in such a way as to imply the presence of a tone not actually
present; then fool everyone by not landing on it. Land somewhere else.
What is being fooled ? Not the ear but the mind
. The whole question is or could be a way of living
 Several stories oc–
. I have a story.
cur to me that I should like to approach. A company of several
There was once a man standing on a high elevation. distance that in Euro–
men who happened to be walking on the road noticed from the Because we are
pean thinking, things are seen as good or not good.

in the direct
you may choose to
isn't it
to appreciate a
to hear it without
is giving a
. But
Live happily
Now

at any instant
turn to it
never return to it
Of course, it is
the people either
A lady from
We have
have no
highly fractional
it, it
to.
nothing that
is the
whom I
There is
pulsion
and I am
I need it
the tables of
Music of
sometimes
.
everything's
drink a
be a
time to
Now for a

situation:
avoid it
.
piece of music,
the unavoidable,
lecture which
taking off again and
ever after.
?

one may leave it
.
.
always changing but
a–gree or they don't
Texas said:
no music in
music in Texas
.
supports itself
Each something
supports it
last one who is
will mention
always activity
.
saying it
.
sounds,
Changes is"
gently pleasing.
Now contemporary
changing
glass of water
masterpiece
talk when
little about

It is.
, but what
At the root
to call it this
extraneous
brings us back to
returning to the
And do we?

Kansas has
and whenever one
Or you may leave it
America is the
now it is very clearly
and the differences of
I live in Texas
Texas.
is that the

.
is the
.
changing
.
but it is
I have nothing
and that is
"All that you
durations,
as you
what–
music is
we could simply
.
you have
you have
accepting,

If you don't like it,
silence requires
of the desire
rather than that,
new sounds
contemporary music
Book of Changes.
Forever?

this about it:
wishes one may re–
forever and
oldest country.
changing, so that
opinion are clearer.
.
The reason they
durations are
If you let
You don't have
celebration of a
Pierre Boulez
contemporary music

free from com–
to say
poetry as
say regarding
amplitudes, in your
may see: boring,
ever you like
changing but since
decide to
For something to
to have enough
nothing to say.
naturally,

finally . It is a discipline, which, accepted,
in return accepts whatever. I was silent. Now
I am speaking. No melody. No counterpoint. Now the fifth and last part:

 In other words, there is no split be–
tween spirit and matter. And to realize this, we have only
suddenly to a–wake to the fact .
 I have noticed it happens and
when it does it partakes of the miraculous .
Going on about what someone said: A thing leads
to other things whereas a musical instrument leads to nothing.
Just as going from here to Egypt is a single trip
but a more or less complex series of experiences or just as
Chinese characters are some written with one stroke but
others with two. But if you avoid it, that's a pity because it re–
sembles life very closely and life and it are essentially a cause for joy.
People say, sometimes , timidly : A vacant lot
, a piece of string and a sunset ,
possessing neither , each acts .

--

Ramakrishna spent an afternoon explaining that everything is God. Afterward, one of his disciples entered the evening traffic in a euphoric state and barely escaped being crushed to death by an elephant. He ran back to his teacher and asked, "Why do you say everything's God when just now I was nearly killed by an elephant?" Ramakrishna said, "Tell me what happened." When the disciple got to the point where he heard the voice of the elephant's driver warning him several times to get out of the way, Ramakrishna interrupted, "That voice was God's voice."

• • •

I was surprised when I came into Mother's room in the nursing home to see that the TV set was on. The program was teenagers dancing to rock-and-roll. I asked Mother how she liked the new music. She said, "Oh, I'm not fussy about music." Then, brightening up, she went on, "You're not fussy about music either."

This lecture was written for the Beta Symposium at Wesleyan University, February 1961, while I was a Fellow at the University's Center for Advanced Studies. I was one of several members of the academic community all of whom, including President Victor Butterfield, were addressing the students on the same subject. I made my lecture on fifty-six cards, twenty-eight with texts, twenty-eight with numbers. (The numbers were numbers of seconds.) Directions for the use of the cards, followed to obtain the arrangement given below, were these:

Shuffle the cards with texts. Ascertain the position of the one having the story about Goldfinger and Schoenberg. Shuffle all of the cards with numbers, reserving that having the number 120. Place that one in the numbers-deck in the position corresponding to that of the Goldfinger-Schoenberg story in the texts-deck. Using a stopwatch, read the texts in the corresponding time-lengths. This provides a twenty-minute talk. Other numbers cards could be made in order to provide a talk of another length.

The typography is an attempt to provide changes for the eye similar to the changes varying tempi in oral delivery give to the ear.

LECTURE ON COMMITMENT

In order to fulfill all our commitments, we need more ears and eyes than we had originally. Besides, the old ones are wearing out. In what sense am I losing my ear for music? In every sense.

-
-
-
-
-
-
-

50

To do? Or is it already done for us? What did we do to be born? Did we, after con-

sideration, choose life here rather than on another planet or in another solar system, feeling there were better opportunities on Earth? That we would get farther?

•
•
•
• **35**

Say, through some bull-headed commitment, you get yourself into a bad situation. The wisest thing to do would be to get out of it as gracefully as possible (to order a retreat if you happened to be a general).

•
•
•
•
•
•
•
• **55**

The question is not: How much are you going to get out of it? Nor is it: How much are you going to put into it? But rather: How immediately are you going to say Yes to no matter what unpredictability, even when what happens seems to have no relation to what one thought was one's commitment?

•
•
•
•
•
•
•
• **60**

When I first went to Paris, I did so instead of returning to Pomona College for my Junior year. Looking around, it was Gothic architecture that impressed me most. And of that architecture I preferred the flamboyant style of the fifteenth century. In this style my interest was

attracted by balustrades. These I studied for six weeks in the Bibliotheque Mazarin, getting to the library when the doors were opened and not leaving until they were closed. Professor Pijoan, whom I had known at Pomona, arrived in Paris and asked me what I was doing. (We were standing in one of the railway stations there.) I told him. He gave me literally a swift kick in the pants and then said, "Go tomorrow to Goldfinger. I'll arrange for you to work with him. He's a modern architect." After a month of working with Goldfinger, measuring the dimensions of rooms which he was to modernize, answering the telephone, and drawing Greek columns, I overheard Goldfinger saying, "To be an architect, one must devote one's life solely to architecture." I then left him, for, as I explained, there were other things that interested me, music and painting for instance. Five years later, when Schoenberg asked me whether I would devote my life to music, I said, "Of course." After I had been studying with him for two years, Schoenberg said, "In order to write music, you must have a feeling for harmony." I then explained to him that I had no feeling for harmony. He then said that I would always encounter an obstacle, that it would be as though I came to a wall through which I could not pass. I said, "In that case I will devote my life to beating my head against that wall."

<div align="right">120</div>

Seriously, shall we get with it?

-
-
-
-
-

<div align="right">30</div>

Now we come to the subject of discontinuity in relation to commitment. Say I'm committed. Say somebody interrupts me while I'm working. If I let him (which is what I did when I was conceived), then I get discontinuity. I can of course say: No; don't bother me, thereby losing the opportunity of renaissance.

-

<div align="right">25</div>

Which is wrong? The weather or our calendars? This is supposed to be the worst month; maybe everything has slipped out of position.

<div align="center">*114*</div>

·
·
·
·
·
·
·

50

There's the example of someone devoting himself to one square foot of earth, hoping before his end of time to learn what he could about everything in that small plot. (Apparently at no point in time or space is the wall impenetrable. Push or not, and the door opens.)

·
·
·
·

40

Every now and then you run into the assumption that if one person is committed others will commit themselves, following suit, as it were. This is implicit in the current activities involving civil disobedience, to say nothing of education, apprenticeship, and the whole rigamarole. Do we then measure our success by how much we reduce the human race to sheeplikeness? Contrast the Far Eastern animal who on a winter night getting sleepy pulls himself up into a tree letting the snow continue to fall so that he leaves no traces.

·
·

45

"Music also is a means of rapid transportation." Hui-Neng, who later became the Sixth Patriarch, was dishwasher in the monastery's restaurant.

·
·
·

30

I have a friend whose actions resemble overwhelming inspirations. Constantly changing in her course, she

nevertheless does fully whatever it is she is doing, so that I would say she is committed. She would like, however, she told me, not to have two of everything, but just one, so that she could be utterly concentrated. When she told me this I was surprised, because I thought she was committed in the first place, and because I myself feel more committed the more diverse and multiplied my interests and actions become.

 25

I never had a hat, never wore one, but recently was given a brown suede duck-hunting hat. The moment I put it on I realized I was starved for a hat. I kept it warm by putting it on my head. I made plans to wear it especially when I was going to do any thinking. Somewhere in Virginia, I lost my hat. **20**

You might say commitment is ultimate reality seen from the human point of view. Therefore it is our daily business to find practical ways of turning the telescope around and looking through the other end.

•

• **25**

Who first stepped in this puddle anyway? And how did this mud get to be so luscious?

•

•

• **20**

One observes everywhere alteration, sometimes slight, in a course of action. Might we not have been born, not men, but a flock of birds? (She asked me how I could explain the fact that the tall fat girl in the Theatre Class had been able to give everyone the impression that she was a short stubby pencil.)

•

•

•

• **40**

Our Western education teaches us caution. And so we hesitate before crossing the great waters. We wouldn't want, would we, to throw ourselves away? Realizing we might have been elected President of the United States, we want somehow to settle for a life not too ignoble. Well, there's always Madison Avenue. And it needs us to keep itself going.

·
·
·
·
·
· **60**

One might say, Let yourself go, but then what if he laughed at the wrong moment or in some other way was embarassing to himself and us? So we say, Dedicate yourself to what you're going to do. That means you must study. When you study, do you study a thing or do you study with someone? Could you do it alone or would you have to have a teacher whose disciple you'd become? (I believe everything you say.) (The entire theory of harmony, such as it is, was rediscovered by a New Englander without benefit of any contact with Europe; when it was envisaged in China, an imperial decree was given forbidding it.)

· **45**

Why was I asked to speak on commitment? Do I not resemble a grasshopper?

·
·
·
·
·
·
· **45**

Let me say it schematically. This point is it. That point is you. We draw an arrow between the two points, indicating that you have dedicated yourself to it, unquestioningly. That is commitment. Where does it get you? Well, there are lines from that point that is it that are arrows to every other point in space and time. Any "it" is like a Grand Central Station, or rather a space platform in orbit. Once there, you can move out in any direction. You can float through the air, as Mila Repa did, in the form of a thistle. Appear in several places at the same instant (the way the mass media do). You can even come back to yourself: toward the end of his life, Rama-

krishna put a rope of flowers around his own neck and cross-legged sat in self-worship.

• **50**

What was it actually that made me choose music rather than painting? Just because they said nicer things about my music than they did about my paintings? But I don't have absolute pitch. I can't keep a tune. In fact, I have no talent for music. The last time I saw her, Aunt Phoebe said, "You're in the wrong profession." **20**

I'll tell you one thing: being committed as I am now to commitment is very odd. As Gertrude Stein said, "There isn't any there there." If only it were a pearl, I could reach to my forehead and find it. As Suzuki said: Living in the city I don't see how you're going to do it; living in the country you'd have a chance. And there's his article entitled *Hands*. (Let them get dirty. And who was it said something about roots— not just the roots but the dirt attached to them? Compare the trees sent to Nebraska which refused to grow simply because their roots had been cleaned up.)

• **40**

Is it true that when a murder is committed, each one of us is the murderer? If so, then ought we not be more generous to one another?

•

•

•

• **30**

As he says, there are already so many sounds to listen to. Why then do we make music? Consider, he says, one's relation to music like that to, for example, animals, weeds, stars, garbage, or people one may never meet again, provided one is not exclusively professional keeper, breeder, disposer, or exploiter of these.

•

•

•

•

•

• **55**

Must we then (in order to be taken seriously by ourselves and our fellow men), must we lie awake at night in preparation for decision? The dark night. Or is it that the sun is just too bright and we by it are blinded?

-
-
-
-
-
-
-
- **60**

We are not committed to this or that. As the Indians put it: Neti Neti (Not this Not that). We are committed to the Nothing-in-between—whether we know it or not. (My heart goes on beating without my lifting a finger whether I'm dodging the traffic or stuffing my stomach. Perspiration?)

-
-
-
-
-
-
- **55**

In order to think must I wear my thinking cap? Will it be sufficient just to bite my lips? Or, if I am in a room, will pacing back and forth like an animal in a cage, will that do the trick? Can't I just plain think?

-
-
-
- **35**

We are as free as birds. Only the birds aren't free. We are as committed as birds, and identically.

-
-
-
-
- **35**

In October 1961, Gyorgy Kepes, Professor of Visual Design at M.I.T.'s Department of Architecture, invited me to write an article that would appear in a book on the module, one of a series of books devoted to problems of form that he was preparing for the publisher, George Braziller. Kepes suggested that I discuss not only the module, but rhythm, proportion, symmetry, beauty, balance, etc. I declined, saying I wasn't interested in any of those things. Kepes wrote back to say he hoped I would write a text in any case, that I might do so as the devil's advocate.

Thus in a corner, I tried to figure out where Kepes possibly could have found that list of subjects (and why he had thought of asking a musician to discuss questions concerning vision). Living next door to an amateur architect who was deeply impressed by Le Corbusier, it dawned on me that the words might have come from Le Corbusier's book, *The Modulor*. I ran next door, picked up the book, opened it. Sure enough, there they were, all of the words, plus an account of Le Corbusier's love of music, all of which explained to me why Kepes had thought of writing to a musician.

I then made use of my *Cartridge Music* to write a text. *Cartridge Music* is a number of materials with directions for their use. There are twenty ordinary non-transparent sheets having biomorphic shapes. There are several transparent plastic sheets, one having points, a second having small circles, a third having a meandering dotted line, a fourth representing the face of a chronometer. By superimposing all the transparent sheets on that ordinary one which had the same number of biomorphic shapes that Kepes had given me subjects, and by adjusting the meandering line so that it intersected at least one point within one of the shapes and made at least one entrance and exit with respect to the chronometer, I was able to make a detailed plan for writing. Points within shapes were ideas relevant to a particular subject, points outside were irrelevant ideas. The circles were stories, likewise relevant and irrelevant. The numbers on the chronometer were interpreted, not as seconds, but as lines in stenographic notebooks. I arrived, that is, at directives like the following: from line 24 to line 57, tell a story that is relevant to proportion, discuss an idea about rhythm, follow this with an idea that has nothing to do with balance. Obtaining many such directives, I then did the writing. Empty spaces follow from the method I've described. In oral delivery (I've often given this text as a lecture) the empty spaces are represented by silences. When I finished the writing, May 1962, I wrote the headnote given below. Gyorgy Kepes accepted my work and it was published in the volume on *Module, Proportion, Symmetry, Rhythm* in the Vision and Value Series edited by him for George Braziller, New York, 1966.

RHYTHM ETC.

The principal characters in the following text are Le Corbusier, architect of beautiful buildings, inventor of the Modulor, and David Tudor, musician, without whom my later music and the musics of Morton Feldman and Christian Wolff, to mention only three, would never have come into being, not because of his virtuosity but because of what, when his skills are put away, he is. This text is not for him but is an homage to him.

There's virtually nothing to say about rhythm for there's no time. We've yet to learn the rudiments, the useful means. But there's every reason to believe that this will happen and not over dead bodies. When I see everything that's to the right resembles everything that's to the left, I feel just as I do in front of something where there's no center of interest at all. Activity, busyness:—not of the one who made it (his intentions had moved down to next to nothing)—perhaps a speck of dust.

We are constructed symmetrically (with the usual allowances for imperfection and ignorance with regard to what goes on inside) and so we see and hear symmetrically, that is, notice that each event is at the center of the field in which we-it is. This is not so much a democratic point of view as it is equally aristocratic. We only object when someone calls our attention to something which we were about to see originally. He mentioned going backward or to the side and combined this with the notion of progress.

The house in Los Angeles the others visited. They told about it: how the people tried to get it destroyed ("an eyesore") but that it proved to be too great a source of income. She spoke of change in her perception of light. As I pick up my thought now I already know that it is going to slip through my fingers. Its very nature is to evade being caught. That is what thought does (not just this one: that things are in the fluent relationship of life and death, death coming only to him who wins: nothing stops).

Before leaving the earth altogether, let us ask: How does Music stand with respect to its instruments, their pitches, the scales, modes and rows, repeating themselves from octave to octave, the chords, harmonies, and tonalities, the beats, meters, and rhythms, the degrees of amplitude (pianissimo, piano, mezzo-piano, mezzo-forte, forte, fortissimo)? Though the majority go each day to the schools where these matters are taught, they read when time permits of Cape Canaveral, Ghana, and Seoul. And they've heard tell of the music synthesizer, magnetic tape. They take for granted the dials on radios and television sets. A tardy art, the art of Music. And why so slow? Is it because, once having learned a notation of pitches and durations, musicians will not give up their Greek? Children have been modern artists for years now. What is it about Music that sends not only the young but adults too as far into the past as they can conveniently go? The module? But our choices never reached around the globe, and in our laziness, when we changed over to the twelve-tone system, we just took the pitches of the previous music as though we were moving into a furnished apartment and had no time to even take the pictures off the walls. What excuse? That nowadays things are happening so quickly that we become thoughtless? Or were we clairvoyant and knew ahead of time that the need for furniture of any kind would disappear? (Whatever you place there in front of you sits established in the air.) The thing that was irrelevant to the structures we formerly made, and this was what kept us breathing, was what took place within them. Their emptiness we took for what it was—a place where anything could happen. That was one of the reasons we were able when circumstances became inviting (changes in consciousness, etc.) to go outside, where breathing is child's play: no walls, not even the glass ones which, though we could see through them, killed the birds while they were flying.

Even in the case of object, the boundaries are not clear. (I see through what you made if, that is, the reflections don't send me back where I am.) But why argue? The Indians long ago knew that Music was going on permanently and that hearing it was like looking out a window at a landscape which didn't stop when one turned away.

Etc. Some time ago counting, patterns, tempi were dropped. Rhythm's in any length of time (no-structure). Aorder. It's definitely spring—not just in the air. Take as an example of rhythm anything which seems irrelevant.

What's marvelous is that the moon still rises even though we've changed our minds about whether or not we'll ever get there. Symmetry. Pure symmetry. Doesn't exist. (He worked for several years and as he worked his technique improved but he preferred to keep the ineptitudes, to reveal, that is, not something perfect but something that showed that he had been alive while making it.) And yet I know when I see something that at least makes the signs of symmetry that I am where measurements no longer have real significance. (Like his flags and targets, alphabets and the cans of ale.) Don't tell me it's a question of mass production. Is it not rather that they want to establish, if not the rules of the game, at least what it is that one uses to play with when he starts playing? (There is no need for us to agree that play is what it is, since in that case Invention without which we might as well not have been born is a spoilsport.) There was a time (and I would not have minded living then even though I would not for any money change places with anyone past, present, or future) when, in Music, there was a glimmer of perfection—a relationship between the unit and the whole, down to the last detail: so elegant. How did that come about (it was an object)? It was an icon. It was an illustration of belief. Now do you see why what we do now is not at all what it was then? Everything now is in a state of confusing us, for, for one thing, we're not certain of the names of things that we see directly in front of us. (But even if we don't know their names, can we not take our rules—and compasses—and measure them? No, we cannot: remember what he said about the tiger.) And no, again: they've required the campers to leave the park because the fires in distant places are sixteen in number.

Ancient history: *tatami* (material); *tala* (structure open at both ends); isorhythmic

motet (closed structure); a rhythmic structure—micro-macrocosmic, the relation of small parts within each unit being identical with the relation of large parts within the whole—(closed structure); the Modulor (material).

She told me she'd dropped in around eleven-thirty in the evening and he said, "Why don't you stay for dinner?" His cooking, she said, was like a performance. There was no running about the room: everything was mysteriously in the very place his hand reached when the need for it arose.

The world in a grain of sand (or is it the universe?) and vice versa. Yes, but when we say as one artist to another, "The unit and its relationship to the whole," we speak of an object, and it is well to remember that the only time the idea of movement on the part of this object entered his head, except as a farfetched analogy to music of previous times, was when he was forced to accept errors into his calculations. (Rhythm, too, is not arithmetic.) (*He* had not made mistakes: it was just that circumstances were overwhelmingly different than the idea with which he was attempting to cloak them. And his idea, actually, he said, was a tool, an instrument— not an object. But it had in it all the elements (present only as measurements) that the object, once made, was to have. Thus it was not a tool, for paper, once cut, is free of the knife which was used to cut it. Not a tool but an instrument, like the piano, which, used, leaves its notes scattered all over the music that was played. (Was that not why it was necessary to change it? Otherwise we would have been faced with a project like that of the Pittsburgh maker of stringed instruments who wanted to so fashion his 'cellos, violas, and violins that one wouldn't be able to hear any difference in timbre, passing from one to another. The problem is more serious: we must dispense with instruments altogether and get used to working with tools. Then, God willing, we'll get some work done. It can be put this way too: find ways of using instruments as though they were tools, i.e., so that they leave no traces. That's precisely what our tape-recorders, amplifiers, microphones, loud-speakers, photo-electric cells, etc., are: things to be used which don't necessarily determine the nature of what is done. There are, of course, pitfalls, but so is one's finger when he points at the moon. What we're dealing with is not things but minds. What else?)

We are now back on the ground on our feet. The cars can no longer pass over the bridge. Last week it was a case of uncertain footing, quicksand, and, before we got out, plunging through the stream. I remember the story he told of their having to

stop altogether—and they were not timid souls. Symmetry's not produced in music by doing something and then doing it backward or by doing something and then something else and then back to what was first done. Exercise: lying flat on your back, your arms at your sides, your legs uncrossed, ask yourself: Among all the sounds I hear, which ones are off balance?

There'll be centrally located pulverized Muzak-plus ("You cling to composition.") performed by listeners who do nothing more than go through the room.

There are those who think or feel that it should never have happened but (disregarding them) the others no longer say, "Perhaps it would have been better had you cut it." They say instead, "I was just getting with it." Some say, "Couldn't you have made it more effective?"

And when that comes about that has not yet been heard, will we be able to say more or less than we can now about the unit and its relationship to the whole? In the interior of that space, open yet filled like a dish to the brim with sounds both gentle and terrifying, occurring at unpredictable points not only in time but throughout the space, too, will it not be as it is today, spring definitely here (or is it summer?), finally outdoors, deliciously plagued by insects, something to hear on all sides (even back of me), that anything we may think we will have had to say will as now have somehow slipped our minds?

His response to the question was: There seems to be a tendency toward the Good. And what does that have to do with proportion? This, that once the measurements

are made (not in rubber but in some inflexible material), the proper relationships determined (Can you believe it? They managed to get an entire family out of the house simply because she raised her children in a way the other mothers didn't), a police force is in order. I quote (omissions and italics mine): "Concord between men and machines, sensitivity and mathematics, a harvest of prodigious harmonies reaped from numbers: the grid of proportions. This art . . . will be acquired by the effort of men of good will, but it will be contested and attacked. . . . *It must be proclaimed by law.*" Art this is called. Its shape is that of tyranny. The social inflexibility follows from the initial conception of proportion. The line there drawn between two points becomes first a web and finally three-dimensional. Unless we find some way to get out we're lost. The more glass, I say, the better. Not only the windows, this year, even though they're small, will open: one whole wall slides away when I have the strength or assistance to push it. And what do I enter? (It draws me like a magnet.) Not proportion. The clutter of the unkempt forest. (His music gave me the same experience: it was only one sound amplified and recorded on tape from the action of two people who for twenty-odd minutes rubbed metal ash trays against panes of glass. That is one way. There are as many others as there are people and there are more people now than at any other time in history. Now the increase in population is geometrical; soon again it may be a question of simple addition. There is *ergo* no lack of ideas which we have not yet had. Why then do other people get his ideas before he does? A short circuit? Let them mend their ways, starting wherever they are constantly from scratch.)

Let us list our reasons for having dropped all thoughts about proportion: 1) We are dealing not with the number 2 but with the number 1; 2) During any one year— the record proves it—we worked in at least two different ways: it took in some cases three or even four years, unburdened as we were, to drop those habits; 3) Being slow-witted, musicians were able to observe the effects of thoughts about proportion in the other arts, giving them the responsibility to do otherwise and fortunately they were free of the problems of architecture and civil engineering (the leaking roof and the collapsing structure), the problems of language (meaning of words and conventions of syntax), the problems of painting and sculpture (objectification); 4) Process, pure subjectivity; 5) Consideration of the activity of listening (We do our own listening: it is not done to us)·—that to be direct it must not be followed by any other activity formed (intellectual) or uninformed (emotional, kinesthetic, critical, discursive), thus making possible a transformation of experience (which was which?

the sounds or I?); so: composition—that to be direct it must not be preceded, etc. until "which was which?" which is crossed out since nothing has yet been performed, i.e., come into existence; 6) We have found ways of composing indeterminately, writing on sheets of transparent plastic which can be superimposed in any ways; and 7)—it took three years to realize the necessity—We have found that one notation is all that should go on a single such sheet (no proportion = optimum flexibility = any proportion). This brings to mind the Russian chickens. Fragmentation. We began by increasing the differences between the sounds making a *klangfarbenmelodie*. More and more we left openings in our space of time. What changed matters radically was the willingness to stop work altogether before the structure was complete. After that there was no longer any fixed structure: just parts in any number, superimposition, and duration. Time-sense changed. Now he says: The permeation of space with sound.

The copperhead strikes only one hunter. The others go on about his business. Again last night, the bird, was it blinded? Was that my purpose in killing it?

He made an analysis of the sound of a gong and then, in order to make a piece of music on magnetic tape, derived measurements from that analysis so that all the frequencies, durations, etc. would follow from these. And even though "anything can be done" this project had to suffer as the other one did the introduction of approximations. What we are concerned with now is quantity (we get quality automatically), but we don't want to be drowned by it: we insist on being able to feel as though nothing were there even though we can no longer count our possessions. If, and I don't believe it, anything like design took place before they put those rocks in those gardens of sand, then it is high time one of us hunters takes time off to make a

garden empty-minded. What would it be? Something else to study?

At this moment if proportion and such matters were uppermost in our minds, harmony and beauty and all the rest of it, we would desire no further change (except we need some rain—six fires yesterday so that two thousand were sent back to the cities they came from): there was an indefinite whiteness sitting in the air around the trees and I was moving along at forty miles an hour. If, as is the case when I look at that building near Chicago, I have the impression it's not there even though I see it taking up space, then module or no module, it's O.K. But don't get me started counting sheep! What we musicians are expecting to discover is not how to stop counting (we've done that already) but how to dispense with our watches. (It's true: I'm always asking him, "What time is it?") It must be that eventually we will have a music the relationship of which to what takes place before and after ("no" music) is exact, so that one will have the experience that no experience was had, a dematerialization (not of facts) of intentions. We already have this, so there's no cause for alarm, but we want it in the future available everywhere, just as it is already. They're beginning to work.

She had a goat. She no longer does. Now they have dogs and the plan to get rid of them. The cat which she's had for a long time has no mother instinct. They're going to buy a horse. Why don't they do as with the view from the balancing rock near the top of the hill, never bothering to see it? Proportion.

Aperiodic rhythm admits of periodic rhythm. (It doesn't work the other way around; that's why it has to be aperiodic, though that isn't how the decision that it should be aperiodic was reached. It was thought that another expression was possible with its own rules and so, though changed, strict control was maintained.—I'm speaking of the people on the other side of the Ocean.) The bird goes on singing repetitively even though the flies are buzzing at the window erratically and intermittently. In all of this, and I do not mention the 9,997 other events, where do we begin if work con-

sists in measuring? And if we begin, say at any point, do we measure each single event, how much time it takes, or do we measure the spaces between events (were there any?) or both? The Northwest Indians began as though they'd lost their powers of singing and dancing (as though they were at Death's door) and then into them came other powers, those of another, a bird or an animal, full of the vigor of new birth. In this case no strict control was maintained. The fire was not avoided. When the dancer could no longer move, others came and carried him back to the place where he had been sitting. Those in Asia also began, but meditatively, as though they didn't know their own minds. The power of another and what other? If, as we needn't, we give an image of it (as they did with the drone for pitches and the proportions of a particular *tala*), what will we in our impartiality give? The others, perhaps, will cite Confucius and the Southwest Indians, but even there the Spider Goddess will not permit the passage of anyone lacking impurities. Apparently we are going north in our sense, that is, of what it is that we must bring in our arts into existence. He called it *allagermanica* and warned against the use of compasses. (I don't have one; the one I borrowed I only used once: to draw the image of a watch—which I trust won't be necessary again. I don't have one because I know perfectly well that once a circle is drawn my necessity is to get outside of it. We begin therefore without it and it is getting urgent by the minute not to erase the clock but to drop the way we used it.)

To change the subject. What do I mean when I say: He has no time-sense? Shifting from one situation to another at appropriate moments? For this reason we made our work experimental (unpredictable). a) We used chance operations. Seeing that they

were useful only where there was a definite limitation in the number of possibilities, b) we used composition which was indeterminate of its performance (characterized in part by parts independently made by each performer—no score). Seeing that that was useful only where there was a change of consciousness on the part of each performer, c) we use performance which is indeterminate of itself.

Chopping our way through the forest trying for our own sakes to give the impression that our visit never took place. Our minds are already changed (and they know it: that's why they call us cold and dehumanized); what remains to be done is to find out what tools are at our disposal and how to use them so that our objective is never seen in the distance but rests continually inside each one of us, so that whenever one goes, as he will, in all directions at once, it with him will go polymorphically. They speak of evolution. Where is there sense of proportion? Talk talk talk: is that what we must put up with? What is necessary is to listen to what you say so that the purpose-lessness of the listening can somehow get into what you're saying. He used the word latent and said that was when he was able to understand. How in heaven's name did anyone get the idea that proportion took place in an object outside of him? A little

flexibility of mind and one is able to see it wherever he looks. She objected to the position of the tree on the island and we all laughed. Not the perception of the proportions of things outside of us but the experience of identification with whatever's outside of us (this is obviously a physical impossibility; that's why it's a mental responsibility). When we tell of something in our experience, they answer with evidence to the effect that just the same thing happened to them. Conversation should be more affluent, each remark unfolding unsuspected ideas and turns of thought. Where our sense of proportion was violated, it no longer is, just as the most common variety of anything is nowadays a rare experience. We still have a few prejudices hanging around and even if we don't remove them ourselves dear friends come in and do it for us.

What am I dealing with when I deal with proportion? Going to the store to buy something? Standardization and mass production and containers (this was his most striking evidence) for packing comestibles for distribution anywhere on the globe? But look closely. This idea (and each one of the others too in typical Mediterranean fashion) is earth-bound: the project is not about space but about packing things so efficiently that space is used up. Examples are given from ship-building and one could certainly find others in the machines that today orbit the earth. But I suspect my father is right: that space travel will be facilitated by not going against gravity but by going with the field—not the gravitational one but the universal electrostatic one. No great expense or force will be required. One will in a wasteful American way simply move off into space inefficiently, i.e., with enough room in the vehicle so that he won't feel cramped during the journey. Furthermore, that wastefulness of space will be a *sine qua non:* size itself will determine whether or not the unforced journey is feasible. You might therefore say that we meet at another point the naturalness of proportion, a law of nature. No doubt there is a threshold in all matters, but once through the door—no need to stand there as though transfixed—the rules disappear. This is not far away from the world of hi-fidelity which in its deadening search for perfection is unintentionally revealing to him the lively musical steps to be taken and in detail. Needless to say, these steps are not only in the opposite direction (when you say do, I'll do don't), they are in all directions. Whenever anyone speaks informatively with precision about how something should be done, listen, if you can, with great

interest, knowing his talk is descriptive of a single line in a sphere of illuminating potential activity, that each one of his measurements exists in a field that is wide open for exploration.

Having this view we find fertility in whatever is inappropriate, providing it's practical. (I mean: we don't intend to just do nothing.) Exaggerate the need for no ulterior motives: consider success of any kind a disastrous failure. (Beware of losing what isn't in your head.) They apparently lost their sense of proportion: they blew the whole thing up and yet only presented a fragment. The result is that nothing has the right size. An obvious mistake. Yet that they're brilliant people is proven by the original and useful arrangement of numbers for the days, the weeks, and the months.

--

I was twelve years old. I got out my bicycle and rode over to KFWB. They said, "What do you want?" I said, "I'd like to give a weekly radio program for the Boy Scouts." They said, "Are you an Eagle?" I said, "No, I'm a Tenderfoot." They said, "Did the Boy Scouts send you?" I said, "No, I just got the idea and came over." They said, "Well, run along." So I went over to KNX. They liked the idea and arranged a time for the first program. I then went to the Boy Scouts, told them what had happened, and asked for their approval and cooperation. They said it was all right to give the program but that they would not cooperate. In fact, they never did. Every time I asked for the Boy Scout band, they said No. Individual Scouts all gave their services willingly. There were boy sopranos; trumpet, trombone, and piano soloists; and Scouts who spoke on their experiences building fires and tying knots. The volume of fan mail increased each month. After two years, the organization called up KNX, said they'd never authorized the program, and demanded that I be put out and they be put in. They were. The band finally played. A few weeks later, KNX took the program off the air.

• • •

When Valerie Bettis first got into the movies, someone interviewed her, asked how it felt to be successful. She said, "What do you mean? I've always been a success."

• • •

Pointing out the five cars in her front yard, the cleaning lady said they were wrecks her son had accomplished during the past year, that he planned to put parts of them together to make a single usable car for her. "The only thing we don't have," she said, "is a good pair of headlights. You know it's very hard to come out of a wreck with undamaged headlights."

Since the fall of 1965, I have been using eighteen or nineteen stories (their selection varying from one performance to another) as the irrelevant accompaniment for Merce Cunningham's cheerful dance, *How to Pass, Kick, Fall, and Run*. Sitting downstage to one side at a table with microphone, ashtray, my texts, and a bottle of wine, I tell one story a minute, letting some minutes pass with no stories in them at all. Some critics say that I steal the show. But this is not possible, for stealing is no longer something one does. Many things, wherever one is, whatever one's doing, happen at once. They are in the air; they belong to all of us. Life is abundant. People are polyattentive. The dancers prove this: they tell me later backstage which stories they particularly enjoyed.

Most of the stories that are in this book are to be found below. (The first thirty formed the text of a lecture titled *Indeterminacy: New Aspect of Form in Instrumental and Electronic Music,* which I delivered at the Brussels Fair in 1958. They were printed under that title in *Die Reihe* No. 5 [German edition copyright © 1959 by Universal Edition A.G., English edition copyright © 1961 by Theodore Presser Company] and are here reprinted by permission.) Other stories appear elsewhere, giving, it is hoped, what adjacent articles in newspapers sometimes give: an occasion for changing one's mind.

HOW TO PASS, KICK, FALL, AND RUN

One evening when I was still living at Grand Street and Monroe, Isamu Noguchi came to visit me. There was nothing in the room (no furniture, no paintings). The floor was covered, wall to wall, with cocoa matting. The windows had no curtains, no drapes. Isamu Noguchi said, "An old shoe would look beautiful in this room."

* * *

You probably know the one about the two monks, but I'll tell it anyway. They were walking along one day when they came to a stream where a young lady was waiting, hoping that someone would help her across. Without hesitating, one of the monks picked her up and carried her across, putting her down safely on the other side.

The two monks continued walking along, and after some time, the second one, unable to restrain himself, said to the first, "You know we're not allowed to touch women. Why did you carry that woman across the stream?" The first monk replied, "Put her down. I did two hours ago."

* * *

Once when several of us were driving up to Boston, we stopped at a roadside restaurant for lunch. There was a table near a corner window where we could all look out and see a pond. People were swimming and diving. There were special arrangements for sliding into the water. Inside the restaurant was a juke box. Somebody put a dime in. I noticed that the

music that came out accompanied the swimmers, though they didn't hear it.

* * *

One day when the windows were open, Christian Wolff played one of his pieces at the piano. Sounds of traffic, boat horns, were heard not only during the silences in the music, but, being louder, were more easily heard than the piano sounds themselves. Afterward, someone asked Christian Wolff to play the piece again with the windows closed. Christian Wolff said he'd be glad to, but that it wasn't really necessary, since the sounds of the environment were in no sense an interruption of those of the music.

* * *

133

One evening I was walking along Hollywood Boulevard, nothing much to do. I stopped and looked in the window of a stationary shop. A mechanized pen was suspended in space in such a way that, as a mechanized roll of paper passed by it, the pen went through the motions of the same penmanship exercises I had learned as a child in the third grade. Centrally placed in the window was an advertisement explaining the mechanical reasons for the perfection of the operation of the suspended mechanical pen. I was fascinated, for everything was going wrong. The pen was tearing the paper to shreds and splattering ink all over the window and on the advertisement, which, nevertheless, remained legible.

. . .

It was after I got to Boston that I went into the anechoic chamber at Harvard University. Anybody who knows me knows this story. I am constantly telling it. Anyway, in that silent room, I heard two sounds, one high and one low. Afterward I asked the engineer in charge why, if the room was so silent, I had heard two sounds. He said, "Describe them." I did. He said, "The high one was your nervous system in operation. The low one was your blood in circulation."

. . .

Years ago in Chicago I was asked to accompany two dancers who were providing entertainment at a business women's dance party given in a hall of the YWCA. After the entertainment, the juke box was turned on so everybody could dance: there was no orchestra (they were saving money). However, the goings-on became very expensive. One of the arms in the juke box moved a selected record on to the turntable. The playing arm moved to an extraordinarily elevated position. After a slight pause it came down rapidly and heavily on the record, smashing it. Another arm came into the situation and removed the debris. The first arm moved another selected record on to the turntable. The playing arm moved up again, paused, came down quickly, smashing the record. The debris was removed by the third arm. And so on. And meanwhile all the flashing colored lights associated with juke boxes worked perfectly, making the whole scene glamorous.

. . .

After he finished translating into German the first lecture I gave at Darmstadt last September, Christian Wolff said, "The stories at the end are very good. But they'll probably say you're naïve. I do hope you can explode that idea."

. . .

Down in Greensboro, North Carolina, David Tudor and I gave an interesting program. We played five pieces three times each. They were the *Klavierstück XI* by Karlheinz Stockhausen, Christian Wolff's *Duo for Pianists*, Morton Feldman's *Intermission #6*, Earle Brown's *4 Systems*, and my *Variations*. All of these pieces are composed in various ways that have in common indeterminacy of performance. Each performance is unique, as interesting to the composers and performers as to the audience. Everyone, in fact, that is, becomes a listener. I explained all this to the audience before the musical program began. I pointed out that one is accustomed to thinking of a piece of music as an object suitable for understanding and subsequent evaluation, but that here the situation was quite other. These pieces, I said, are not objects, but processes, essentially purposeless. Naturally, then, I had to explain the purpose of having something be purposeless. I said the sounds were just sounds, and that if they weren't just sounds that we would (I was of course using the editorial we)—we would do something about it in the next composition. I said that since the sounds were sounds, this gave people hearing them the chance to be people, centered within themselves, where they actually are, not off artificially in the distance as they are accustomed to be, trying to figure out what is being said by some artist by means of sounds. Finally I said that the purpose of this purposeless music would be achieved if people learned to listen. That when

they listened they might discover that they preferred the sounds of everyday life to the ones they would presently hear in the musical program. That that was all right as far as I was concerned.

However, to come back to my story. A girl in the college there came back backstage afterward and told me that something marvelous had happened. I said, "What?" She said, "One of the music majors is thinking for the first time in her life." Then at dinner (it had been an afternoon concert), the Head of the Music Department told me that as he was leaving the concert hall, three of his students called, saying, "Come over here." He went over. "What is it?" he said. One of the girls said, "Listen."

During that Greensboro concert, David Tudor and I got a little mixed up. He began to play one piece and I began to play a completely different one. I stopped, since he is the pianist he is, and I just sat there, listening.

• • •

When I told David Tudor that this talk on music was nothing but a series of stories, he said, "Don't fail to put in some benedictions." I said, "What in heaven's name do you mean by benedictions?" "Blessings," he said. "What blessings?" I said, "God bless you everyone?" "Yes," he said, "like they

say in the sutras: 'This is not idle talk, but the highest of truths'."

• • •

There was an American man from Seattle who went to Japan to buy screens. He went to a monastery where he had heard there were very special ones and managed to get an interview with the Abbot, who, however, didn't say a word during the entire time they were together. Through an interpreter, the American made known his desires, but received no comment of any kind from the Abbot. However, very early the next morning, he received a telephone call from the Abbot himself, who turned out to speak perfect English and who said that the American could not only have the screen he wanted for a certain price, but that, furthermore, the monastery possessed an old iron gate that he could also purchase. The American said, "But what on earth would I do with an old iron gate?" "I'm sure you could sell it to a star in Hollywood," the Abbot replied.

• • •

We've now played the *Winter Music* quite a number of times. I haven't kept count. When we first played it, the silences seemed very long and the sounds seemed really separated in space, not obstructing one another. In Stockholm, however, when we played it at the Opera as an interlude in the

dance program given by Merce Cunningham and Carolyn Brown early one October, I noticed that it had become melodic. Christian Wolff prophesied this to me years ago. He said—we were walking along Seventeenth Street talking—he said, "No matter what we do it ends by being melodic." As far as I am concerned this happened to Webern years ago. Karlheinz Stockhausen once told me—we were in Copenhagen—"I demand two things from a composer: invention and that he astonish me."

• • •

Two monks came to a stream. One was Hindu, the other Zen. The Indian began to cross the stream by walking on the surface of the water. The Japanese became excited and called to him to come back. "What's the matter," the Indian said. The Zen monk said, "That's not the way to cross the stream. Follow me." He led him to a place where the water was shallow and they waded across.

• • •

Another monk was walking along when he came to a lady who was sitting by the path weeping. "What's the matter?" he said. She said, sobbing, "I have lost my only child." He hit her over the head and said, "There, that'll give you something to cry about."

• • •

In New York, when I was setting out to write the orchestral parts of my *Concert for*

Piano and Orchestra which was performed September 19, 1958, in Cologne, I visited each player, found out what he could do with his instrument, discovered with him other possibilities, and then subjected all these findings to chance operations, ending up with a part that was quite indeterminate of its performance. After a general rehearsal, during which the musicians heard the result of their several actions, some of them—not all—introduced in the actual performance sounds of a nature not found in my notations, characterized for the most part by their intentions which had become foolish and unprofessional. In Cologne, hoping to avoid this unfortunate state of affairs, I worked with each musician individually and the general rehearsal was silent. I should let you know that the conductor has no score but has only his own part, so that, though he affects the other performers, he does not control them. Well, anyway, the result was in some cases just as unprofessional in Cologne as in New York. I must find a way to let people be free without their becoming foolish. So that their freedom will make them noble. How will I do this? That is the question.

Question or not (that is to say, whether what I will do will answer the situation), my problems have become social rather than musical. Was that what Sri Ramakrishna meant when he said to the disciple who asked him whether he should give up music and follow him, "By no

means. Remain a musician. Music is a means of rapid transportation to life everlasting"? And in a lecture I gave at Illinois, I added, "To life, period."

. . .

People are always saying that the East is the East and the West is the West and you have to keep from mixing them up. When I first began to study Oriental philosophy, I also worried about whether it was mine to study. I don't worry any more about that. At Darmstadt I was talking about the reason back of pulverization and fragmentation: for instance, using syllables instead of words in a vocal text, letters instead of syllables. I said, "We take things apart in order that they may become the Buddha. And if that seems too Oriental an idea for you," I said, "Remember the early Christian Gnostic statement, 'Split the stick and there is Jesus!' "

. . .

Well, since Darmstadt, I've written two pieces. One in the course of a fifteen-minute TV program in Cologne. The other is *Music Walk,* written during two hours in Stockholm. Neither piece uses chance operations. The indeterminacy in the case of *Music Walk* is such that I cannot predict at all what will happen until it is performed. Chance operations are not necessary when the actions that are made are unknowing. *Music Walk* consists of nine sheets of paper

having points and one without any. A smaller transparent plastic rectangle having five widely spaced parallel lines is placed over this in any position, bringing some of the points out of potentiality into activity. The lines are ambiguous, referring to five different categories of sound in any order. Additional small plastic squares are provided having five non-parallel lines, which may or may not be used to make further determinations regarding the nature of the sounds to be produced. Playing positions are several: at the keyboard, at the back of the piano, at a radio. One moves at any time from one to another of these positions changing thereby the reference of the points to the parallel lines.

. . .

Kwang-tse points out that a beautiful woman who gives pleasure to men serves only to frighten the fish when she jumps in the water.

. . .

Once when I was to give a talk at Teachers College, Columbia, I asked Joseph Campbell whether I should say something (I forget now what it was I was thinking of saying). He said, "Where is the 'should'?"

. . .

Have you ever noticed how you read a newspaper? Jumping around, leaving articles unread, or only partially read, turning here and there. Not at all the

way one reads Bach in public, but precisely the way one reads in public *Duo II for Pianists* by Christian Wolff.

. . .

A Chinaman (Kwang-tse tells) went to sleep and dreamt he was a butterfly. Later, when he awoke, he asked himself, "Am I a butterfly dreaming that I am a man?"

. . .

An Eskimo lady who couldn't speak or understand a word of English was once offered free transportation to the United States plus $500 providing she would accompany a corpse that was being sent back to America for burial. She accepted. On her arrival she looked about and noticed that people who went into the railroad station left the city and she never saw them again. Apparently they traveled some place else. She also noticed that before leaving they went to the ticket window, said something to the salesman, and got a ticket. She stood in line, listened carefully to what the person in front of her said to the ticket salesman, repeated what that person said, and then traveled wherever he traveled. In this way she moved about the country from one city to another. After some time, her money was running out and she decided to settle down in the next city she came to, to find em-

ployment, and to live there the rest of her life. But when she came to this decision she was in a small town in Wisconsin from which no one that day was traveling. However, in the course of moving about she had picked up a bit of English. So finally she went to the ticket window and said to the man there, "Where would you go if you were going?" He named a small town in Ohio where she lives to this day.

. . .

Four years ago or maybe five, I was talking with Hidekazu Yoshida. We were on the train from Donaueschingen to Cologne. I mentioned the book by Herrigel called *Zen in the Art of Archery*; the melodramatic climax of this book concerns an archer's hitting the bull's eye though he did so in total darkness. Yoshida told me there was one thing the author failed to point out, that is, there lives in Japan at the present time a highly esteemed archer who has never yet been able to hit the bull's eye even in broad daylight.

. . .

The Four Mists of Chaos, the North, the East, the West, and the South, went to visit Chaos himself. He treated them all very kindly and when they were thinking of leaving, they consulted among themselves how they might repay his hospitality. Since they had noticed that he

had no holes in his body, as they each had (eyes, nose, mouth, ears, etc.), they decided each day to provide him with an opening. At the end of seven days, Kwang-tse tells us, Chaos died.

. . .

Now and then I come across an article on that rock garden in Japan where there's just a space of sand and a few rocks in it. The author, no matter who he is, sets out either to suggest that the position of the rocks in the space follows some geometrical plan productive of the beauty one observes, or not satisfied with mere suggestion, he makes diagrams and detailed analyses. So when I met Ashihara, the Japanese music and dance critic (his first name escapes me), I told him that I thought those stones could have been anywhere in that space, that I doubted whether their relationship was a planned one, that the emptiness of the sand was such that it could support stones at any points in it. Ashihara had already given me a present (some table mats), but then he asked me to wait a moment while he went into his hotel. He came out and gave me the tie I am now wearing.

. . .

An old rabbi in Poland or some place thereabouts was walking in a thunderstorm from one village to another. His

health was poor. He was blind, covered with sores. All the afflictions of Job were his. Stumbling over something he fell in the mud. Pulling himself up with difficulty, he raised his hands towards heaven and cried out, "Praise God! The Devil is on Earth and doing his work beautifully!"

• • •

Morris Graves used to have an old Ford in Seattle. He had removed all the seats and put in a table and chairs so that the car was like a small furnished room with books, a vase with flowers and so forth. One day he drove up to a luncheonette, parked, opened the door on the street side, unrolled a red carpet across the sidewalk. Then he walked on the carpet, went in, and ordered a hamburger. Meanwhile a crowd gathered, expecting something strange to happen. However, all Graves did was eat the hamburger, pay his bill, get back in the car, roll up the carpet, and drive off.

• • •

A woman who lived in the country was asked how cold it had been the previous winter. "Not very cold," she replied. Then she added, "There were only three or four days when we had to stay in bed all day to keep warm."

• • •

An Irish hero whose mother had died was required by his stepmother to set out on a journey to an island beneath the sea and to bring back some golden apples he would find there. Should he fail to return within a year, he would lose his right to the throne, relinquishing it to one of his stepbrothers. For his journey he was given a miserable shaggy nag. No sooner had he set out than the nag said, "Look in my ear. You will find a metal ball Throw it on the path ahead of us and we will follow it wherever it goes." Unhesitatingly the prince did this, and so, proceeding by chance, they passed through many perilous situations. Finally, on the point of success, the horse said to the Prince, "Now take your sword and slit my throat." The Prince hesitated, but only for a moment. No sooner had he killed the horse than, lo and behold, it turned into a prince, who, except for the acquiescence of the hero, would have had to remain a miserable shaggy nag.

• • •

A young man who was concerned about his position in society and who was about to get married made his wife-to-be promise not to indulge further in kleptomania. (She had, for instance, once gone into the Piggly-Wiggly, taken a number of items, attempted an exit without paying, been stopped and told item by item what she had stolen, given up those mentioned, crossed the street, sat down on the curb, and eaten a jar of peanut butter the attendant had failed to notice.) She promised her husband-to-be she would never steal anything again. But years later, when they were getting divorced, she told him that when they went to the jeweler's to get the wedding ring, she had left him for a moment while he was considering the relative merits of two rings and, not being observed, had acquired a wrist watch.

This particular girl was a great beauty. When a friend of hers who had been a tutor in the Japanese royal family was giving a lecture in Santa Maria, California, she was at the back of the capacity audience standing on a table, wearing high heels, fur coat, and a red rose in her black hair. At one point in his lecture, when the speaker's eye fell on this girl in recognition, she opened her coat, showing herself to be stark naked.

• • •

Some years ago on May 30, Mary Fleming noticed a strange amanita growing near her house in Upper Nyack. She picked the plant, volva and all, and put it to dry in the sun on top of her station wagon. A little later before driving into town she took the mushroom off the car and put it up on an outside window sill, also in the sun. When she did this, she may have been thinking, consciously or unconsciously, of putting the mushroom out of the reach of her cats. She had, at the time, nine of them. At any rate, when she returned home after having

run an errand in Nyack, two Siamese cats, Poom Poom, a mother, and One Yen, her kitten, were busy eating the amanita. Three other cats, not Siamese, were standing nearby interested in what was going on. Only about a third of the amanita remained uneaten. Six hours later, the Siamese became ill. They vomited and had diarrhea. Instead of walking, they staggered around. They suffered peristalsis. Eventually they were quite unconscious. They couldn't move at all. When Mary Fleming took them to the doctor, they were "like two fur boards." They were given injections of atropine. They recovered completely. Twelve days later there was a thunderstorm. One Yen, the kitten, died in the driveway. Autopsy showed that the cause of death was heart attack. The mother, Poom Poom, still lives but has never had another litter.

That's one story. Another version is quite different. It wasn't a cat that died in the driveway, but a dog. What happened was that five days before the thunderstorm, Mary Fleming went to Trinidad where her husband was collecting snakes. She stayed there for a month. Back home in July she found that three of the cats that had recovered from the mushroom poisoning were sick. This means —since One Yen was already dead—that at least two of the ordinary cats not only observed the Siamese eating the amanita but themselves partook. $2-1+2=3$. The three cats who were sick in July were taken to the

doctor who said they had enteritis. He was able to cure them. The cause of One Yen's death is unknown. Perhaps it was the atropine. Since Mary Fleming was in Trinidad there was no autopsy. One thing is certain: Poom Poom is sterile.

• • •

Muriel Errera's house is next to the Royal Palace in Brussels. She said she'd like to give a dinner party and would invite whoever I wanted her to, plus, of course, her friends. Since I was staying in the country south of the city, I asked whether she'd like me to bring along some mushrooms. She said certainly. I arrived at the party with several baskets. I forget what all I had found, but one basket was nothing but *Lepiota* caps fit for the people next door. I was taken in an elevator four flights up to a small improvised kitchen. After making certain that everything I would need for cooking was available I went back downstairs. I met the guests and had some drinks and then, after the first few courses, went upstairs again, this time to cook the mushrooms. It didn't take long. I got myself and the pans into the elevator and pushed the button. I no sooner left the fourth floor than the lights went out and the elevator stopped running. I lit a match and looked for an emergency button, but there wasn't any. Feeling hurried, I began beating on the elevator door and shouting. After quite some time,

I heard some voices, and after that the voice of my hostess. She said that word was being sent to the contractor who had installed the elevator and did I want something to read? I said that it was quite dark and that I didn't require any reading matter. The contractor never arrived, but eventually all of the servants, including the cook, the chauffer, and the doorman, went down to the basement and by their joint efforts sent me inch by inch back up to the fourth floor. The first thing I did was to reheat the mushrooms. As we walked downstairs together, Muriel Errera asked me not to mention the incident to any of the guests. When I arrived with the frying pans in the candle-lit dining room, every one was eating dessert.

• • •

Last October when it was terribly dry I went to visit the Browns in Rochester. I didn't take along any mushroom books, even though I knew that Nobby and I would spend most of our time walking through the woods. No matter where he lives he gets ahold of those United States Coast and Geodetic Survey quadrangle maps. He studies them carefully and with their aid explores the countryside conscientiously. He is not a botanist. He is more of a hiker. He likes a good view and solving the puzzle of how to get out of the woods once he is in them. He took me to a swampy area ordinarily no

doubt impassable but because of the drought quite easy to explore. There to my surprise we discovered a white *Tricholoma* growing in rings larger than any I had ever seen before. This particular species was new to me. It appeared in every respect desirable and it was not acrid to the taste. We gathered quite a lot and I decided to telephone W. Stephen Thomas, tell him about the mushroom, and learn from him what species it was.

He answered the telephone but didn't recognize the fungus from the information I gave him. He said that there was a scheduled walk the very next day and that someone in the Rochester Club might know my plant. No one did, but one person had Groves along, which I consulted and was pleased to learn described my *Tricholoma*. It was *irinum*, edible and delicious. I served it to a number of students from the University who came to the Browns' the following day for dinner.

A week later I was home again and got to cataloging my mushroom books. I came across a reprint of an article by Alexander Smith entitled *Tricholoma irinum*. Smith tells in detail how for years he has found and eaten this mushroom without any ill effects, how he never had any compunction about giving it to others to eat until two people were seriously poisoned by it. He studied their case quite carefully since he is himself so often sickened by fungi but not by this

one. He came to the conclusion that the mushroom, nothing else that had been eaten or drunk, was indeed responsible.

• • •

Certain tribes in Siberia trade several sheep for one *Amanita muscaria* and use the mushroom for orgiastic practices. The women chew the raw mushroom and the chewed pulp is mixed with blueberry juice. This is drunk by the men and is productive of hallucinations. It also changes the relation between the ego and social ideals. Thus, the urine of those who have been affected by the mushroom is in high demand and is drunk with pleasure, for it contains a sufficient amount of the drug to continue its wild effects. The Vikings who went berserk are thought to have done so by means of this same mushroom.

Nowadays we hear of biochemical experiments using *Amanita muscaria* or other hullucinatory mushrooms or the drugs synthesized in imitation of them—experiments in which professors, students, or criminals become temporarily schizophrenic, sometimes for the novelty of it, other times for purely scientific purposes. Just as we soon will travel to the moon and other earths, and add to our telephone conversations the practice of seeing one another while we speak, so one will do with his mind what he now does with his hair, not what

it wants to do but what he wants it to do. People in the near future will not suffer from schizophrenia; they will simply be schizophrenic if and when they have the desire.

Life is changing. One of the ways I'm trying to change mine is to get rid of my desires so that I won't be deaf and blind to the world around me. When I mention my interest in mushrooms, most people immediately ask whether I've had any visions. I have to tell them that I'm very old-fashioned, practically puritanical, that all I do is smoke like a furnace—now with two filters and a coupon in every pack—and that I drink coffee morning, noon, and night. I would also drink alcohol but I made the mistake of going to a doctor who doesn't permit it. The visions I hear about don't interest me. Dick Higgins said he ate a little *muscaria* and it made him see some rabbits. Valentina Wasson ate the divine mushrooms in Mexico and imagined she was in eighteenth-century Versailles hearing some Mozart. Without any dope at all other than caffeine and nicotine, I'll be in San Francisco tomorrow hearing some of my own music and on Sunday, God willing, I'll awake in Hawaii with papayas and pineapples for breakfast. There'll be sweet-smelling flowers, brightly colored birds, people swimming in the surf, and (I'll bet you a nickel) a rainbow at some point during the day in the sky.

The thought has sometimes occurred to me that my pleasure in composition, renounced as it has been in the field of music, continues in the field of writing words, and that explains why, recently, I write so much. I know however that sometime soon I will renounce that too. I admired Buckminster Fuller when he began his lecture at the YMHA in New York in the spring of 1966 by saying that he never read prepared texts for he didn't want to do for his audiences what they individually could do for themselves, i.e., read. Having these feelings, and invited by the Once Group to Ann Arbor with David Tudor for their Festival in September 1965, I decided to improvise a talk. David Tudor had collected a number of throat-, lip-, and other microphones and various electronic components for modulating sound. He prepared a sound-system having six channels for which I was to be the sound-source. He had the assistance of Gordon Mumma, composer and founder of a company that manufactures electronic music components called Cyber-sonics, Inc. I wrote down the topics given below I was interested in talking about. (I had intended that there would be one hundred and twenty-eight subjects, but I didn't get this number written.) I also asked Robert Ashley, composer and one of the Once Group to converse with me and/or to elect for that purpose anyone else in the audience who was willing to do likewise. He conversed for awhile, then left; shortly Bob Raushenberg appeared and we talked. Very little of anything that was said, due to the manipulations of the sound-system by David Tudor and Gordon Mumma, was comprehensible to the audience. The performance was an entire evening (one and a half to two hours).

It took place under the night sky on the roof of a building, all floors of which, including the one we were on, were ordinarily devoted to the parking of automobiles. With the help of several others, I arranged the folding chairs so that they were not in rows but, to all appearances, haphazardly placed. I was surprised to see shortly after the performance began that the audience had arranged itself in rows. They were seated facing in the direction of the roofed-over stairwell, one flight above them at one corner of the building, where David Tudor, Gordon Mumma, Robert Ashley (later Robert Rauschenberg) and I were seated in the midst of electronic equipment. The loud-speakers surrounded the audience.

After it became evident what they were "in for," quite a number of people present went away. Those who remained enjoyed themselves, sat in pairs and informal circles, sent delegates off to the town below. These returned with refreshments, six-packs of beer, etc.

At the suggestion of Andrea Chiyo, film-maker, my lists are not printed in columns or rows but are scattered on the following pages, somewhat as we had arranged the chairs in Ann Arbor.

TALK I

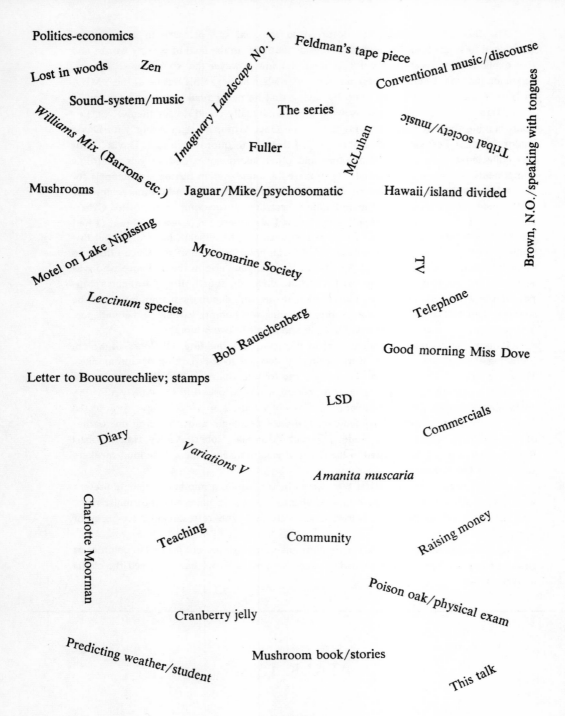

Politics-economics

Lost in woods Zen

Sound-system/music

Imaginary Landscape No. 1

Feldman's tape piece

Conventional music/discourse

Williams Mix (Barrons etc.)

The series

Fuller

McLuhan

Tribal society/music

Brown, N.O./speaking with tongues

Mushrooms Jaguar/Mike/psychosomatic

Hawaii/island divided

Motel on Lake Nipissing

Mycomarine Society

Leccinum species

Bob Rauschenberg

TV

Telephone

Good morning Miss Dove

Letter to Boucourechliev; stamps

LSD

Commercials

Diary

Variations V

Amanita muscaria

Charlotte Moorman

Teaching Community

Raising money

Poison oak/physical exam

Cranberry jelly

Predicting weather/student Mushroom book/stories

This talk

Measurements

Emma Lake/Black Mountain

Hearing with feet

Animals/India

Variations IV/copyright

Alloways/Jasper Johns

Ives

Solo for Piano

Regina/living underground

Indian Bread

Toronto Electronic Music Studio

Rhythm Etc.

Seriously,

Trees

Tulane interview

North Pole changing Betsy

Ichiyanagi

Kaprow/*Theatre Piece*

Judgment/curiosity *Diary*

Cough/clear throat What's a score?

Williams Mix Writing vs. music

Sea urchins/vibraphone *I-Ching*

Aaron Copland

Advertisements

Changes in breakfast French/language

Jasper Johns Date book Name-dropping/omission of names

Duchamp Voice as poetry N.Y.C./India. Shocking?

Telephone book "More like a cookie" Student of weather

Newspaper/discuss Paula's letter Judith's telephone/interruption

Food-gathering Changes in aquariums Charleston, West Virginia

Letters Taxi driver press charges Packaging/Indian problem

Change of citizenship

Housing service/Fuller

Visit of strangers/drive to Ann Arbor

N.Y.C. Fair/S.F. Fair

Numbers of people/Emma Lake

Indian designs: floral, geometric

Perform on subway platforms

Coincidence/example?

Life in air: as though in air

Sixty-one global services

Jay Watt/to die in six months/cats

Maine/afraid we knew too much

Pies in Canada/no food distribution

Mushroom likes and dislikes

Variations V

Notion of seasons changing

Painting/bowing (of string instruments)

100 m.p.h./David Tudor's remark

Artist in residence/good, but not in residence better

Suzuki/structure of mind

Japanese mushroom poem

Disappearance of syntax/Joyce

Electronics when lost in the woods

What we need to know now is: How many services do we require?

Copland fungi: no diatonic effect

Lecture: What do we know? and What do we need to know?

If payment required, many credit cards/if none, one

American Foreign Policy/Fulbright

Lecture on sex in fungi/destruction of sieve arrangement

"One thing leads to another"

Give up equation of work-money-virtue

Undirected variation (in-out) (sameness-new)

Scientific attitude re fungi

Ann Arbor/telephone book?

Recipe for *Marasmius oreades*

Argument vs. agreement

Theatre in the round/audience in the round

Now that the following text is written (it was published in the summer of 1967 by the Something Else Press, New York City, as a part of their Great Bear Pamphlet Series, using a color structure which followed a suggestion by Dick Higgins), I plan, circumstances permitting, to write further on the same subject. Just before Christmas I visited my mother who lives in a nursing home. (Two years ago she suffered a severe heart attack which left her physically helpless.) I told her I'd written three texts on world improvement. She said, "John! How *dare* you? You should be ashamed!" Then she added, "I'm surprised at you." I asked her, in view of world conditions, whether she didn't think there was room for improvement. She said, "There certainly is. It makes good sense."

DIARY: HOW TO IMPROVE THE WORLD
(YOU WILL ONLY MAKE MATTERS WORSE)
CONTINUED 1967

LXI. U.S. citizens are six per cent of world's population consuming sixty per cent of world's resources. Had Americans been born pigs rather than men, it would not have been different. Finding one of them acceptable, people say, "You're not like an American." She said people she talked to about the global services (and the notion services'd bring about global living without war) said: Yes, of course, that's right. But how is it going to happen? Deep drilling: a slight angle and without meaning to you're taking oil from under someone else's property. Erik Satie's Venetian gold-merchant: He hugs the bag of gold, takes some pieces out, kisses them,

carefully putting them back. After other
 financial-erotic acts, not being able
 to resist, he gets into the bag
 himself. Coming out of it somewhat later,
he discovers he has a backache. LXII. We
 open our eyes and ears seeing life
each day excellent as it is. This
 realization no longer needs art though
without art it would have been difficult
 (yoga, zazen, etc.) to come by.
 Having this realization, we gather
 energies, ours and the ones of
nature, in order to make this intolerable
 world endurable. Robots. Ivan
 Sutherland: " . . . it is not enough for
 a computer to print an answer. The
 answer is useful only when it leads
to new human understanding Widespread
 use of graphic inputs and outputs
 with computers will bring about a major
 increase in scientific, engineering, and
 educational productivity." LXIII. We
 talked about Gaudi. Mies van der Rohe
 admired the Gaudi buildings in and near
 Barcelona and the Park Güell. Laura
 said that driving to the apartment
 from the office Mies was
misanthropic. He had said that there are
too few good people in the world. (Duchamp
 talking about the human mind pointed
out how poorly it works.) Isolate aspect
of human nature which brought it about no
 one (not even those devoted to his
 work) knows how many pieces of Satie's
 Furniture Music were written or where
 they are. Call it collective

146

thoughtlessness. There exist, we're
told, unused areas of the brain. They
 should be put to work. LXIV. Days
spent hunting for non-synthetic foods. At
sunset becoming artists in the kitchen.
 Other days spent making something inedible
 (painting, theatre, etc. and the
 sciences), paying attention to things
 already made (classics, history,
 humanities). **Plastics.** Waddington: " . . .
the richness of individual life depends to
 a major extent on constructive
 enterprises . . . which are on such a large
 scale that only society as a whole can
 undertake them." Effortless speed
(seven hundred and fifty miles per hour):
people blown through tunnels downhill from
Boston to New York. Effortless slowing
down: tunnel goes uphill. Asked about
religion he said he never said anything
 against it: "It's the only thing that
 keeps people in line." What about
 art? Is art, formerly religion's servant,
 now, without our realizing it, a kind of
 policing activity? We need a purely
 secular morality. **LXV. Pia** Gilbert,
born in southern Germany, got in a
taxicab in New York City. The driver
 said, "I'm a Black Muslim." She
replied, "I'm sorry to hear it." "You
 don't believe in the truth?" "That
 isn't the truth." "You don't like
 Negroes?" "What makes you think I'm not
a Negro?" What it is is a field. Looks
 like we'll have networks in that
 field. Lines crisscrossing on a

147

multiplicity of levels. There'll be, as
 ever, the nothing-in-between. **Wrist**
watches with alarms that tell us as we
travel around when we should eat (not
when the airline hostess gives us
food, but when, according to our own
systems, we should have it). **New function**
for doctors: adjusting our wrist
alarms. LXVI. "They dance the world as
it will be . . . is now when they
dance." Technique. Discipline.
Ultimately it's not a question of
taste. It's the other way around.
Each thing in the world asks us, "What
makes you think I'm not something you
like?" *The use of drugs to facilitate*
religious experience is against the stream
of the times. (He lost interest in the
tape-music center, its experiments and
performances. He went to the
Southwest desert. *He removed himself from*
the others.) Begging: difficult
profession. In India, parents maim
children producing bodies that'll attract
pity. His eyes are sheep's eyes; his
mind's superb. Decided not to give
him a penny. Then did (after reading
letter Satie'd written shortly before
death, asking for a little money, **enough**
so he could sit in a corner, smoke his
pipe). **LXVII. Asked the Spanish doctor**
what she thought about the human
mind in a world of computers. She
said computers are always right but
life isn't about being right. Pia's
defence of property was touching. As

she explained, she and people she knew
had suffered at the hands of others. She
 said that by means of things they like
and acquire people position themselves with
 respect to society. Duchamp: Property
is at the base of it. Until you give up
owning property radical social **change is**
 impossible. We ought either to get
 rid of God or to find Another Who
 doesn't permit mention of trust in Him
 on pieces of money. Or taxation could
 be augmented to the point where no one
 has any money at all. In which case
 we could keep God. LXVIII. Definition
 of the word "cosmopolitan": 1.
Belonging to all the world. 2. At home
 in any country; without local or
 national attachments. 3. Composed
 of elements gathered from all or
 various parts of the world. Bertrand
Russell asks American citizens: Can you
 justify your government's use in Vietnam
of poison chemicals and gas, the
 saturation bombing of the entire
 country with jelly-gasoline and
 phosphorus? Napalm and phosphorus
 burn until the victim is reduced to
 a bubbling mass. Ramakrishna said:
 Given a choice between going to heaven
 and hearing a lecture on heaven, people
 would choose the lecture.
 Electronic Sketching. Engineers
Focus Light on Screen to Design Visually
via Computer. LXIX. Sir Charles Dodds:
 ". . . assume that cancer and
 cardiovascular problems are solved.

149

. . . We shall see institutions filled
with scientists of many biological
disciplines devoting their time to a
study of the ageing process." He says
no evidence exists that age
accompanied by degeneration is or
isn't a natural process. Every
death may have been unnatural, due to
extraneous causes. Lecture series on
War (a summit series): lectures to
be given by heads of states saying
whatever they will on the general
subject of fighting and why one does
doesn't do it. Disgust. Any
proverbs that pass through our heads
should be examined in a spirit of
skepticism, their opposites in some
cases reinforced, e.g., instead of
"A rolling stone gathers no moss"
establish "He doesn't let the grass
grow under his feet." *LXX. Something*
needs to be done about the postal services.
Either that or we should stop assuming just
because we mailed something it will get
where we sent it. **Not just heads of**
state for the Lecture Series on War,
but heads of corporations too. Let it
become household knowledge that being
employed by such and such a company is
no different from being drafted for such
and such a battlefront. "Now's the time.
Never this opportunity again (plans
for centennial celebration: funds
available)." Including in our
awareness whatever's/whoever's exterior
to our focus of attention. In this way

150

eliminating the practices involving
guilt/aggression/conscience, "turning our
backs," John R. Seeley, "on an anal and
phallic world to bring into being a
reign of genitality (enjoyment by
others must be a condition of one's own
enjoyment)." LXXI. Fire. Not
unpleasing additions to water, but the
subtraction from it of noxious
elements. *American school-teacher in
Japan, having been assured she could
have a private bath, told attendant she'd
arranged to be alone. He said, "I'm
here to see that you are."* **Art instead of
being an object made by one person is a
process set in motion by a group of
people. Art's socialized. It isn't
someone saying something, but people doing
things, giving everyone (including those
involved) the opportunity to have
experiences they would not otherwise have
had.** *Indians in northern
Saskatchewan, farmers in l'Isle de
France, they've all forgotten what
wild plants are edible. I was
talking about this loss with Père
Patrice. He said they've also
forgotten how to sing.* **LXXII. The
children have a society of their own.
They have no need for ours. At the
airport Ain said he came simply to see
whether his mother was all right.
Mumma's music (*Mesa*) for Cunningham's
dance called *Place*. Sitting in the
audience I felt afterward as though
I'd been rung through a ringer. Then had**

to play Satie's *Nocturnes,* something **not**
easy for me to do. **Wrong notes all**
over the place. **Tonight the program's**
being repeated. **I've practiced.** **I'll be**
deaf and blind. **Experimentation.**
Summit lecture series on War: not to be
given in one city, but via a global
Telstar-like facility, each receiving set
throughout the world equipped with a
device permitting hearing no matter
what speech in **one's** own tongue. *LXXIII.*
Progress. **Since for long we've been**
saying that money is the root of all evil,
we should get rid of it, lock, stock and
barrel. Take all the people who are
now living in the world, McLuhan told me.
Stand them up. Jammed together, they'd
fit into the New York City subway system.
I asked the skin-doctor why skin-doctors do
such poor work. "Oh," he said, "We
don't do any worse than the other
doctors: it's just that you can see the
results of our work." Portuguese lady
mentioned Lieh-tzu. Story: man, walking
out of stone cliff through fire,
astonishing those who saw him, was
asked how he did it. "What?" Came out
of stone, walked through fire. "I know
nothing," he said, "about either of
those two things." **LXXIV.**
Ephemeralization. **Away from the earth**
into the air. **Or: "on earth as it is**
in heaven." **More with less: van der Rohe**
(aesthetics); Fuller (society of
world men). **Nourishment via odors, life**
maintained by inhalation: Auguste

Comte (Syteme de Politique Positive,
second volume). *Individuality.* Out
of the darkness of psychoanalysis
into sunny behavioral psychology (people
picking up their couches and
walking). **U.S. highway diner: now that**
I haven't eaten the potatoes, they
will throw them away (they should have
been thrown away before being served).
become richer. No way once it
begins to impede accumulation.
Universe. They've put the cart
before the horse: they're better about
publicity than they are about what they
publicize. LXXV. Sometimes the truth
gets out: years ago the double-spread in
a New York newspaper showing the
faces of the forty or so men
(industrialists) who rule the world.
All of her children were male, twelve
of them. "She should be studied," Duchamp
said. "She is the solution of a
problem." A suite for two. **Instead of**
transformation into other forms
(reincarnation) regeneration of each
individual. Precedent: constant
remaking of Shinto temples in Japan. (With
his thumbnail Tudor kept the
bass-string in vibration.) Include
changes in design: invention applied to a
living body. (Electronics:
reincarnation without hiatus of
death.) Remembrandt. We have everything we
used to have. The Mona Lisa's still
with us, for instance. On top of which we
have the Mona Lisa with a mustache.

153

We have, so to speak, more than we need.

LXXVI. *Electric clothing.* The program was changed. We need news. Not just bad news: good news and news that's neither good nor bad. Heads of state lecturing on war (knowing they are speaking to people all over the world) will not be able to promote national objectives. *We were impatient.* *So, we telephoned to find out whether the bus was coming, even though the appointed hour had not yet struck.* Figuéras. Looking for corduroy suit, noticed chamber pots, each with eye and inscription at the base of the bowl, the eye primitively painted with brilliant colors. The Catalan inscription was black: I see thee. **LXXVII.** **He refuses to give up. When he walks across the room, you wonder whether he's going to make it (a strange orientation of the upper body in relation to the legs, an original way of putting one foot in front of the other).** Out of Illinois into Sweden. (How will it happen? Will we do it or will it be done to us? Unemployment.) Climate control. Stravinsky's objection to Schoenberg's music: it isn't modern (too much like, though more interesting than, Brahms'). Absence of modernity's effect of Schoenberg's **accepting tradition, hook, line and sinker.** Sounds everywhere. Our concerts celebrate the fact concerts're no longer necessary. LXXVIII. The rehearsals continued and more concerts were given.

Her playing which had been superb became
merely correct. It was necessary to
 suggest a certain sloppiness, the
playing of something that hadn't been
 written. Computer-made music
 (synthesized Blue Moon) presented
 same problem. Random elements
 introduced. *Dad's cold remedy (a*
cure-all combining menthol, thymol in
 alcohol: Cowell preferred it to
whiskey); Dad's inhalor for quick
introduction to blood stream of vitamins,
 hormones. American Medical
 Association prevented general
 marketing of these products. **The**
 doctor telephoned to ask whether
Grandfather was still alive. Turned out
 that instead of analyzing
Grandfather's urine he had studied some
 apple juice that Grandmother had given
 the hospital messenger when he came to
 pick up the sample. LXXIX. Get it,
she said, so it's unknown which parent
conceiving will bear the child.
 Responsibility undefined. Circa
one hundred and seventy-five kinds of
 male, sixty, seventy kinds of female.
 Sterility. **He had actually gotten slides**
showing the passage of the gene from one
 cell to the next. **Destruction.**
 Reconstitution. **(What we want is very**
little, nothing, so to speak. **We just**
 want those things that have so often
 been promised or stated: Liberty,
Equality, Fraternity; Freedom of this and
 that.) Clothes for entertainment, not

because of shame. Privacy to become an
unusual rather than expected
experience. Given disinfection,
sanitation, removal of social concerns re
defecation, urination. No
self-consciousness. Living like animals,
becoming touchable. LXXX. Ancient
Chinese imperial decree: Burn the
books! To have the books that are not
yet written, prohibit reading the ones on
shelves. Fire takes place of dust
producing beneficent ashes. **Tried
conversation (engineers and artists).
Found it didn't work. At the last
minute, our profound differences
(different attitudes toward time?)
threatened performance. What changed
matters, made conversation possible,
produced cooperation, reinstated
one's desire for continuity etc.,
were things, dumb inanimate things (once
in our hands they generated thought,
speech, action).** Say lecture series
on war cannot be arranged. Rule that
summit meetings must be made public via TV,
satellite, the works. Increase frequency
of summit meetings. One way or
another, that is, let the game be shown for
what it is to those having time and
interest to observe it. *LXXXI. Shirley
Genther's arranging for me to receive the
Kaiser Reports. You don't pay for them.
They just come to you in the mail.*
Speakers for lecture series: Mao
Tse-Tung, Ho Chih Minh, some African
Bushman, Nikita K., LBJ, Charles de

156

Gaulle, etc. *We now expect a good*

deal (that the lights will turn on,

the telephone will work, etc.), what we

want is a comfortable bed (each one

of us has a different notion of

comfort), fresh air, delicious

water, fine food, wine (there again, we

differ). **Into the night: the days to come.**

Barbara said she'd heard the political

situation in some South American country

being what it was (bizarre, dishonest and

meaningless), a gorilla in the zoo was

nominated and elected President.

LXXXII. In music it was hopeless to

think in terms of the old structure

(tonality), to do things following old

methods (counterpoint, harmony), to use

the old materials (orchestral

instruments). We started from

scratch: sound, silence, time,

activity. In society, no amount of

doctoring up economics/politics will help.

Begin again, assuming abundance,

unemployment, a field situation,

multiplicity, unpredictability,

immediacy, the possibility of

participation. Schools we'll live

in (their architecture). Spaces without

partitions. Noticing what the others

are doing (they also think). Giving

no thought to graduation. We know it's a

melody but it's one we've not yet

sung. Power of momentum. LXXXIII.

There are those of course who have no time

for improving the world. They are

struggling to keep it going. Disciplines

that require exercise. Lunch in Chicago:
 She asked me whether it was true that
art no longer interested me. I said I
 thought we'd done it (opened our
 eyes, our ears). What's urgent is
society. Not fixing it but changing it so
 it works. *Self-service.* Time for anger.
 Miscegenation: generation of a
 lasting biochemical change. We gave up
 judgments, substituted poetry.
 Fire engines in the street below.
 Smoke in the halls. Called the desk.
 They said there was no cause for
 alarm. **LXXXIV. "If you and Daddy**
 get a divorce, I'm not going to go
 with you and I'm not going to go
 with Daddy." His mother said, "Where
 would you go then?" "I'd go back to
 nature." North Pole is on the move:
used to be in the Philippines. *They give*
 us food because we're traveling by air.
Pretty soon they'll do the same even when
 we're on the ground (trip or no
 trip). We have only one mind (the one we
 share). Changing things radically,
 therefore, is simple. You just
 change that one mind. Base human
 nature on allishness (soon enough global
 selfishness will become something to think
 about). LXXXV. Political steps
restricted to those taken in front of
 television cameras, so people everywhere
 can see where they're going. Better
 yet: politicians take no political
 steps alone. Politicians (via TV) simply
 make suggestions. Receiving sets

equipped with transmission means
enabling people to vote on whether or not a
proposed step or steps should be taken.
Denial of what one's believed in.
Amplification of the sound of feet,
feet one sees walking. [Talked about
disintegrating passenger at one end of
line, reassembling him at his
destination. Pittsburgh Skybus: push a
button: following a path, bus goes where
you wanted it to go. Northwest plans
for shooting people through tunnels with
compressed air. Graduated speeds for
Synchroveyor travel. Insisted on
private transportation (possibly
electrical: getting home, plug in car:
unused, it gets recharged).] LXXXVI.
The lazy dog (a bomb containing ten
thousand slivers of razor-sharp
steel). In one province of North
Vietnam, the most densely populated, one
hundred million slivers of razor-sharp
steel have fallen in a period of
thirteen months. These razor darts
slice the villagers to ribbons. Maki
thinks Hawaii's another part of
Japan. **Portugal thinks of Angola**
not as a colony but as Portugal.
U.S.A. thinks the Free World is U.S.A.'s
world, is determined to keep it free,
U.S.A.-determined. *The possibility*
of conversation resides in the
impossibility of two people having
the same experience whether or not their
attention is directed one-pointedly. An
ancient Buddhist realization (sitting

159

in different seats). **LXXXVII. Exhaustion.**
Sleep disturbed by dream. Said we were
to have regular tours each year, four of
them, each to last four months.
First one: performances in Alaska,
North Pole, Russia, Finland. Parking at
the super market, she changed her
plan, gathering lamb's quarters, mushrooms,
and horseradish she'd noticed growing wild
outside. Earth a city as Paris was:
people seen in love on the streets.
Electric clothes rechargeable at public
couches, couches provided with
adjustable domes, domes raised or lowered
according to the weather, cataclysmic
events **foreseen and observed as theatre**
from a distance, distance provided by
immediate mass transportation.
Disease removed, the use of faeces,
animal and human, to enrich the earth
(economy, no refuse). Starting over again
from the point of human well-being,
non-fluent factors in **the exchange**
between man and universe (detergents,
for instance) disused. A new
ecology. The enjoyment of "dirt".
("Hands.") **LXXXVIII. The woods: finding a**
cabin nobody's living in. It'll be
fun fixing it up. Details of dawn
observed, unstudied. Success. **All**
desires gratified, we say No but smile at
the same time (taking a rain check).
Blessed are the misers: they shall give
what they have to others. The girls **in**
the cities were forced into teams of
prostitutes for U.S. troops. The Saigon

160

government forced literally tens of
thousands of young girls into camps for
U.S. troops. **Armistice November
Eleventh. When's Second World War's
Armistice? Need three hundred and
sixty-three more wars arranged so each
ends on different day, entire year
becoming one Armistice after another.
Wars cold rather than hot. Lectures on
war preferable to war itself. Annual
celebration of ends of lectures, each and
every day. LXXXIX.** Society, not being a
process a king sets in motion, becomes an
impersonal place understood and made
useful so that no matter what each
individual does his actions enliven the
total picture. Anarchy (no laws or
conventions) in a place that works.
Society's individualized. **The doctor
didn't know what the disease was. It
attacked everyone differently, wherever a
person was vulnerable.** Into that world
when it's changed things'll reenter
we'd renounced, e.g. value judgments (cf.
the dominant seventh). **They'll not
monopolize nor suggest what happens
next.** (He hit over the head the
mother who'd lost her only child,
saying, "This will give you something
to cry about.") Constant
lamentation. (We cry because anyone's
head was struck.) Tears: a global
enterprise. *XC. President Eisenhower
(1953): Let us assume we lost
Indo-China. If Indo-China goes, the
tin and tungsten we so greatly value*

*would cease coming. We are after the
cheapest way to prevent the occurrence
of something terrible—the loss of
our ability to get what we want from
the riches of the Indo-Chinese
territory and from Southeast Asia. If*
we get through 1972, Fuller says, we've
got it made. 1972 ends the present
critical period. Following present
trends, fifty per cent of the world's
population will then have what they need.
The other fifty per cent will rapidly
join their ranks. Say by the year 2000.

Each one of us has his own stomach; it is not the stomach of another. Lois Long likes lamb chops. Esther Dam doesn't. Ralph Ferrara prefers the way his aunt cooks mushrooms to the way anybody else does, to wit in olive oil with garlic. As far as I'm concerned they're cooked in butter, salt, and pepper and that's that. (Now and then with the addition of some cream, sometimes sweet, sometimes sour, and less often a little lemon juice.) Once I followed a recipe for stuffed morels under glass. When we got around to eating them we couldn't tell what we were tasting. The dish suggested fancy restaurant food.

Henry Cowell told me that years ago in Palo Alto two Stanford botany professors assured him that a mushroom he had found was edible. He ate it and was very ill. Realizing he had eaten other things at the same meal and believing that the teachers knew what they were talking about, he tried the mushroom not once but twice again, becoming seriously sick each time.

Charles McIlvaine was able to eat almost anything, providing it was a fungus. People say he had an iron stomach. We take his remarks about edibility with some skepticism, but his spirit spurs us on. Alexander Smith, obliged as a scientist to taste each new mushroom he finds, is made ill by almost every one of them. Mushroom poisoning is nothing to laugh about. Nancy Wilson Ross told me of a gardener on Long Island who had always eaten mushrooms he collected, who made a mistake, nearly killing himself by eating one of the amanitas. He recovered and lives but has never been the same since. He is more or less permanently debilitated. I went out in the woods in northern Vermont without any breakfast. (This was about eight years ago.) I began to eat several species raw. Among them was *Boletus piperatus,* which is said to be edible even though it has pores with red mouths, a danger sign according to many authorities. By noon I was ill, wretchedly so. I was sick for twelve hours. Every now and then I managed to tell the Lippolds, whose guest I was, not to worry, that I wasn't going to die.

. . .

162

AFTERWORD

Not knowing exactly what day a year from Monday—the day eight of us had arranged to meet in Mexico—would be, I decided it was early in June 1967. When people wrote or called asking me to do something in that month, I said No. (Exception: the benefit for the Cunningham Dance Company sponsored by John de Menil to be held at Philip Johnson's home in Connecticut on Saturday, the 3rd of June; Judith Blinken, the Company's and my representative, argued that the first Monday of that month was the 5th: I'd have time to fly.)

Then it occurred to me—see the last paragraph of the Foreword—that I was the only one taking the trip to Mexico seriously. I sent a note to Octavio and Marie-José in India—see the last lines of the second text on world improvement—asking whether they'd meet me on the 5th in Mexico City: "Will that be convenient for you? . . . What a marvelous time we will have!"

Paz's reply was two pages long. The first three paragraphs had nothing to do with our rendezvous. The fourth began: "Now about our trip to Mexico. We would not be able to go in June." Farther along: "Our plans are to be in Europe until the 25th of July. . . . Perhaps we can meet afterward in Mexico or in New York. Let me know about your plans. We really want to see you." There were two more paragraphs and a postscript, all to do with other subjects.

Now I have other plans—for the rest of the year and also for June. In that month there'll be the annual beach banquet of the New York Mycological Society with Joe Hyde cooking on the beach the wild food members gather along the shore. Also I'll go to Montreal to see the Fuller dome and Jasper Johns' *Map of the World According to Buckminster Fuller* which is to be in it. The rest of June and perhaps the summer will be spent working with Dick Higgins and Alison Knowles on *Notations,* a book to be published by the Something Else Press which will illustrate the work of some two hundred and sixty composers who have contributed manuscripts to a collection I've been over two years forming to benefit the Foundation for Contemporary Performance Arts.

What we have to do, then, is not to say Yes or to say No, but simply to go straight on illiterately, updating the way of life Meister Eckhart proposed (just following the general outlines of the Christian life, "not wondering am I right or doing something wrong"), following, that is, the general outlines of Buckminster Fuller's comprehensive design science. There are now six volumes prepared by Fuller in collaboration with John McHale: *Inventory of World Resources, Human Trends and Needs; The Design Initiative; Comprehensive Thinking; The Ten Year Program; World Design Strategy; The Ecological Context: Energy and Materials.* These volumes are published by the World Resources Inventory, Box 909, Carbondale, Illinois. Fuller's other books are available too: *Nine Chains to the Moon, No More Secondhand God, Education Automation, Untitled Epic Poem on the History of Industrialization* (all these are published by the Southern Illinois University Press, Carbondale, Illinois); *Ideas and Integrities* (Prentice-Hall, Englewood Cliffs, New Jersey).

Paz is right. Whether we see one another in Cadaqués, Stony Point, Fairport, Toronto, or New Delhi is of little consequence. We don't have to make plans to be together. (Last July, Merce Cunningham and I ran into Bucky Fuller in the airport outside of Madrid.) Circumstances do it for us.

Changing the world so it works for "livingry" is another matter. Success is essential. The goal, to quote Fuller as he stated it in '63, is: ". . . to render the total chemical and energy resources of the world, which are now exclusively preoccupied in serving only 44% of humanity, adequate to the service of 100% of humanity at higher standards of living and total enjoyment than any man has yet experienced."

How will the change take place? (Susan McAllester, referring to my proposal —see the third text on world improvement—of a Summit Lecture Series on War, said, "I thought you were joking.") The change is taking place 'spiritually,' Marshall McLuhan tells us, without our conscious participation: the media we use are effecting the metamorphosis of our minds and bringing us to our senses. It will be made "definite," Fuller tells us, through intelligent design and implementation thereof on the part of the world's students (unemployed as a result of stepped-up automation, they'll have nothing to do but change the world). "Acts of God"— sudden cutting-off of necessary services (water, electricity, etc.), sudden insufficiency of this or that resource essential to this or that industry—will bring people together in common efforts to recover from crises. The recoveries will be characterized by the "emergence of ephemeralization" (Fuller): doing more with less. That emergencies give men the intelligence to accomplish ever-increasing goals

with ever-decreasing resource inputs Fuller calls the greatest act of God.

Under whose leadership? Not that of the financiers (they think in terms of fictitious profit, splitting society into those who have and those who don't). Not that of the politicians (they divide up the world and then scheme to obtain power for one part at the expense of another). Nor that of the engineers (though Thorstein Veblen's proposal, 1921, of a general strike on the part of the engineers followed by their taking control of the country technologically—where it actually 'works'—is attractive). The leadership must be radical, global, architectural.

Architectural in the sense that Buckminster Fuller uses the word: comprehensive design problem-solving. Some years ago I asked Fuller whether he played chess. He replied that he used to but now only plays the biggest game. I thought he was referring to his activities as a lecturer to students throughout the world. I was mistaken. He was referring to his actual game "How to Make the World Work" soon to be set up at the University of Southern Illinois. This game, computerized, will be played by capable individuals and teams. The computer will be supplied with all relevant and continually updated information regarding location and quantity of world resources, world peoples, their trends and needs, world energy systems, etc. The game will be visibly developed on a Dymaxion Airocean World Map having the size of a football field, a high balcony overlooking it permitting players to see the effect of their 'moves'; theories of how to "facilitate attainment, at the earliest possible moment, by every human being of complete enjoyment of the total planet Earth." By this means, no one will be under anyone's leadership. An order that serves but does not control will be discovered by means of the play of intelligence. That order, through continued world game tournaments "live-televised by a multi-Telstar relay system" will be made endlessly regenerative.

Recently I visited the National Memorial to the Wright brothers at Kitty Hawk, North Carolina. Sixty-four years ago the Wright brothers made the first powered flight, remaining in the air twelve seconds or so and traveling a distance of twenty-odd feet. I read a statement by Wilbur or Orville: "It is not really necessary to see very far into the future to see how magnificent it will be." And then something to the effect that it's just a question of opening the doors.

Many doors are now open (they open according to where we give our attention). Once through, looking back, no wall or doors are seen. Why was anyone for so long closed in? Sounds one hears are music. Mushrooms: we see them everywhere even when we're driving along in the night at forty to sixty miles per hour. The same with world improvement: now that we hunt for signs of practical global anarchy, such

signs appear wherever we look. We see a current use for art: giving instances of society suitable for social imitation—suitable because they show ways many centers can interpenetrate without obstructing one another, ways people can do things without being told or telling others what to do. We look forward to "an environment," N. O. Brown, "that works so well that we can run wild in it." We are evidently going to extremes: to the "very large scale" ("the great impersonality of the world of mass production") and to the "very small scale" ("the possibility of intense personalism") —Edgar Kaufmann Jr., *The Architectural Forum,* September 1966. We anticipate "the dwindling," the eventual "loss of the middle scale" (*Verlust der Mitte*—J. Strygowksy): bureaucracies associated with power and profit. The information with which these bureaucracies now deal in a stalemated fashion (C. Wright Mills: *The Power Elite)* may be relegated to our computers, our unimaginative rationality put down under as in a sewer—N. O. Brown—so that "the reign of poetry"—Thoreau, Brown, and the rest of us—may at long last commence.

Benjamin Franklin's remark doesn't seem silly. He is said to have said: "Gentlemen, you see that in the anarchy in which we live society manages much as before. Take care, if our disputes"—disputes among delegates to the Pennsylvania constitutional convention—"last too long"—they'd already lasted several months—"that the people do not come to think that they can very easily do without us." In the fall of '66, Swedish teachers went on strike. Children, by themselves, proceeded with their own education.

At any point in time, there is a tendency when one 'thinks' about world society to 'think' that things are fixed, cannot change. This non-changeability is imaginary, invented by 'thought' to simplify the process of 'thinking.' But thinking is nowadays complex: it assumes, to begin with, the work of Einstein. Our minds are changing from the use of simple, critical faculties to the use of design, problem-solving, creative faculties, from an unrealistic concern with a non-existent status quo to a courageous seeing of things in movement, life as revolution. History is one revolution after another. "The progress from an absolute to a limited monarchy, from a limited monarchy to a democracy, is a progress toward a true respect for the individual." Thoreau. And again Thoreau: "That government is best which governs not at all, and when men are prepared for it, that will be the kind of government which they will have." If we 'think' in a fixed, unmoving way about "when men are prepared for it," that "when" will seem unattainably in the future. But we live from day to day: revolution is going on this moment. Once we give our attention to the practice of not-being-governed we notice that it is increasing. (As the conversation began, he

smiled and said: There's nothing I disagree with. On our highways the general speed is in excess of the limit. In supermarkets express check-out lines limited to those having eight or ten items regularly serve customers having more. The burning of draft cards. Haight-Ashbury. Tax evasion. Fourteen thousand Americans renounced citizenship in 1966. Civil disobedience. Non-payment of taxes. July '67 racial riots in New Jersey ended by removal of police from disturbed areas.) We are faced with a problem free of our emotions, a problem so simple computers in their infancy can aid in its solution, a technological problem Fuller long ago stated: to triple the effectiveness and to implement the distribution of world resources so that everyone in the world will have what he needs. Renunciation of competition. World-enlightenment. Not a victory, just something natural.

4270 0

HE SAYS:

THEY SAY:

Art's obscured the difference between art and life. Now let life obscure the difference between life and art.

Our first and best all-American dadaist . . . and his prose style is the finest since Gertrude Stein.—*Virginia Kirkus' Service*

Music as discourse (jazz) doesn't work. If you're going to have a discussion, have it and use words.

He can strip away superficiality with the power of a well-aimed machete, while retaining the grace of a prima ballerina.—*New Haven Register*

As often as not it makes sense, but not continuous sense. More like woolgathering done by a wit.
—*Richmond Times-Dispatch*

The truth is that everything causes everything else. We do not speak therefore of one thing causing another. . . . Everything we come across is to the point.

There's a temptation to do nothing simply because there's so much to do that one doesn't know where to begin.

Having nothing to do, we do it nonetheless; our biggest problem is finding time in which to get it done.

Cage's writing does not tell us what to think as much as it makes us think in a particular way. . . . Cage demonstrates in an unpretentious, subtle and forceful way the profound spiritual basis of *avant-garde* art.
—*American Scholar*

Tune him in at any point—and you find yourself traveling at high speed along the new electronic wavelength. What's more, the trip requires no artificial fuels—*New York Times Book Review*

Where there's a history of organization (art), introduce disorder. Where there's a history of disorganization (world society), introduce order. These directives are no more opposed to one another than mountain's opposed to spring weather.

If Cage really wants to "get things done", perhaps he should try to get himself elected to an administrative position or become a social worker.
—*The Listener* (London)

A composer is simply someone who tells other people what to do. I find this an unattractive way of getting things done.

Easily the most joyful book of the year. . . . Cage is to the artist what Dr. Spock is to the mother.
—*National Catholic Reporter*

We are as free as birds. Only the birds aren't free. We are as committed as birds, and identically.

A gas.—*East Village Other*

$2.45

WESLEYAN UNIVERSITY PRESS, *Middletown, Connecticut*